ALSO BY JED PERL

Paris Without End

Gallery Going

Eyewitness

New Art City

Antoine's Alphabet

Magicians and Charlatans

Calder: The Conquest of Time

Calder: The Conquest of Space

AUTHORITY AND FREEDOM

AUTHORITY AND FREEDOM

A Defense of the Arts

Jed Perl

ALFRED A. KNOPF, NEW YORK

THIS IS A BORZOI BOOK
PUBLISHED BY ALFRED A. KNOPF

www.aaknopf.com

Knopf, Borzoi Books, and the colophon
are registered trademarks of Penguin Random House LLC.

Grateful acknowledgment is made to the following
for permission to reprint previously published material:
The Estate of Edwin Denby: Excerpt from "Summer" from *In Private,
In Public* by Edwin Denby. Reprinted by permission of The Estate of
Edwin Denby.
Random House: Excerpt from "The Maker" by W. H. Auden,
copyright © 1961 by W. H. Auden, copyright renewed 1989 by The Estate of
W. H. Auden; from *Collected Poems* by W. H. Auden, edited by Edward Mendelson.
Reprinted by permission of Random House, an imprint and division of
Penguin Random House LLC. All rights reserved.

Library of Congress Cataloging-in-Publication Data
Names: Perl, Jed, author.
Title: Authority and freedom : a defense of the arts / by Jed Perl.
Description: First edition. | New York : Alfred A. Knopf, [2021] |
"This is a Borzoi book"—Colophon.
Identifiers: LCCN 2020047858 (print) | LCCN 2020047859 (ebook) |
ISBN 9780593320051 (hardcover) | ISBN 9780593320068 (ebook)
Subjects: LCSH: Arts—Philosophy.
Classification: LCC BH39 .P356 2021 (print) | LCC BH39 (ebook) | DDC 700.1—dc23
LC record available at https://lccn.loc.gov/2020047858
LC ebook record available at https://lccn.loc.gov/2020047859

Jacket design by John Gall

Manufactured in the United States of America
First Edition
1st Printing

CONTENTS

AUTHORITY AND FREEDOM

1 THE VALUE OF ART

Authority and freedom are the lifeblood of the arts. Whether reading a novel, looking at a painting, or listening to music, we are feeling the push and pull of these two forces as they shape the creator's work. Authority is the ordering impulse. Freedom is the love of experiment and play. They coexist. They compete. Even a child, setting out to write a story, recognizes the authority of certain conventions, if only the need for a beginning, a middle, and an end. To love to look at paintings is to love, almost before anything else, the certainty of the rectangle, the delimiting shape. But why not feel

free to do something different? Why must a story have a beginning, a middle, an end? Why must a painting be on a rectangle? One way of acknowledging authority is by opposing it—by writing, for instance, a story that ends inconclusively, open-endedly. The authority of art functions almost simultaneously as an inhibition and an incitement. The limitations sharpen the fantasy, clarify the feeling—they precipitate freedom.

A century ago the poet Guillaume Apollinaire wrote about this "long quarrel between tradition and invention," and I see no reason to believe that the quarrel will ever end. It shouldn't. It mustn't. Without this quarrel—what really amounts to an epic debate—art doesn't exist. The rival claims of authority and freedom kick off passionate responses and principled stands, both with artists and with audiences. Which is as it should be. But these passions and principles, which are never easy to reconcile or disentangle, can all too easily leave people at loggerheads. Somebody says, "I'll stick with the classics." Another person wonders, "How about something really new?" Conservatives argue for continuity. Radicals demand relevance. Soon a third person announces, "All art is political." Everybody knows we're

navigating perilous waters. When it comes to the arts, who is to say what's conservative and what's radical? Is creative authority inherently conservative? Is creative freedom inherently radical? People of goodwill disagree. Is Jane Austen conservative or radical? Probably both—and neither. A disagreement about a movie or a play, while it may not cut as deep as a disagreement about politics, will cut nonetheless. A shared affection for the work of a particular artist—a novelist, a painter, or a pop singer—can become a bonding experience. Alliances are formed and arguments are advanced—in casual conversations, college classrooms, and foundation boardrooms. What do we think about the work of a writer or a painter who treats women badly? Or an opera that had its premiere in Nazi Germany? What strikes one person as impregnable can strike another as fragile. There are times when the arguments get so heated that they threaten to overwhelm the art.

When questions of authority and freedom and the arts aren't framed in political terms, they're often couched in psychological terms. This isn't surprising. The artist's struggle with authority is intimate and immediate—Freud saw authority as inhering in the

figure of the father—but the struggle is not exclusively or even primarily psychological. When it comes to the arts, I think both political and psychological analogies are inadequate. I prefer to consider authority and freedom in relation to philosophical traditions that go back to ancient times. The authority of the rectangle for the painter or the conventions of beginning, middle, and end for the fiction writer are general, societal, traditional. I will return to these matters later on, but for now it's important to make the point that authority and freedom, as they animate the arts, are overarching, all-encompassing traditions—principles that anybody, whether or not they're actively engaged in the arts, can comprehend. That's what makes them so persuasive—and, on occasion, so provocative. Artists, however much they are shaped by their time and place and by the ideas and ideals that animate their age, must reshape experience. That's their mandate. The reshaping, which turns experience into art, is both artisanal (a matter of mastering the tools of the trade, whether words, colors, shapes, sounds, or movements) and metaphysical (a never-ending competition between the rival claims of authority and freedom). The metaphysical is embedded in the artisanal.

What generations of artists and critics have described (and sometimes dismissed) as formal concerns are much more than that. To write, to paint, to compose is to struggle with what is possible and impossible within the constraints of a medium. For the artist the medium is a world unto itself, but the struggle within the medium is also a way of coming to terms with the struggle between the possible and the impossible that plays out in the wider world. The pacing of a novel, the quality of a painter's brushwork, the sonorities that a composer discovers in the orchestra are transformations of the nature of the novel, the painting, and the symphony that pit the authority of a tradition against the freedom of the individual artist. Creative work raises a series of questions. What do I owe to authority? How do I find freedom within authority? Can I regard freedom as a form of authority? An artist brings to these traditions many personal inclinations and dispositions, but the act of painting, writing, composing, music-making, or dancing sets everything that is personal within a larger context. The singularity of an artistic endeavor—the way the individual works out the dynamic between authority and freedom—is set in a history. That history is everybody's history.

. . .

We understand why Anna, the protagonist of Doris Lessing's novel *The Golden Notebook,* as she sits in her room in London trying to write, finds herself imagining a Chinese peasant or a Third World freedom fighter asking her, "Why aren't you doing something about us, instead of wasting your time scribbling?" In the face of the social, economic, and political challenges that we see all around us, we may find it hard to justify the intensely intimate experience that we have with a novel, a concerto, or a painting. We may fear that the arts are a distraction—a problem. That fear isn't new. Time and again poetry, painting, music, dance, and theater have been viewed as a threat, precisely because there's so much that's unruly and uncategorizable in their power to beguile, enchant, educate, elevate, transport, and transform. More than two thousand years ago Plato worried that a great poet posed a danger to an ideal society; in Renaissance Florence, the Dominican friar Savonarola excoriated what he described as the profanity of the art of his day; and Tolstoy, in *What Is Art?,* the book he published in the 1890s, called

into question his own naturalistic novels along with the work of Dante and Shakespeare. (He character-ized their work as "brain-spun.") In our time of social, economic, environmental, and political anxiety and unrest, many are asking whom the arts speak for. Do they speak for some particular group? Do they speak truth to power? Picasso, reacting to demands that the arts make some simple kind of sense, responded with a riddle: "Art is a lie that makes us realize truth." The question that many people are asking right now—and it's not entirely different from the questions that Plato, Savonarola, and Tolstoy were asking centuries ago—is whose lies and whose truths art is meant to reveal.

Whether encountered in a church, a museum, a jazz club, a movie theater, or a city square, the arts have always been part of the fabric of life. Before an artistic experience is anything else, it's often a critical element in a communal or social experience. So there is cer-tainly something to be said for the argument that the same moral and ethical values and assumptions that we bring to our everyday lives should apply to the life of art. What's missing in this neat equation, though, is any consideration of the capacity that the arts have to

take us out of the workaday world. Isn't that a big part of what has always attracted people to the arts? Most sixteenth-century Venetians who gathered in the presence of Titian's immense altarpiece of the *Assumption of the Virgin* in the Frari church surely felt that they were having a religious experience, not an artistic one; but Titian's masterpiece was there precisely because it had the capacity to heighten and intensify that experience. For much of the twentieth century the audiences that crowded into movie houses were as interested in escaping from their daily cares—or sneaking some intimate moments in the dark—as they were in what was actually being projected on the big screen; but without the presence on the screen of Clark Gable, Judy Garland, and the other great stars, moviegoing would never have exerted such a fascination. At the heart of every encounter with a work of art—whether sacred or secular, public or private, mass-market or avant-garde— there's the enigma of the work itself, which, even when designed to serve some apparently cut-and-dried purpose, only really succeeds when the artist or artists involved are driven by an imaginative imperative.

Some will argue that only in the modern period—

since, perhaps, the late Middle Ages—have artists been guided by a conflict between authority and freedom. Most people will agree that this struggle animates the work of twentieth-century giants like Mondrian and Schoenberg, who hoped to almost totally reimagine the nature of the visual and musical arts. I'm inclined to go further and argue that in all times and places the creative act has involved a struggle, debate, or dialogue between authority and freedom. The struggle plays out against an ever-changing landscape. Subjects, styles, moods, and metaphors change. Through it all, the basic struggle continues. In many earlier periods—in Old Kingdom Egypt, for example—the authority of convention held the artist tight in its grip, but even then virtuosity provided at least some opportunity to express an individual understanding of authority, if only because it took a certain degree of competence to honor a convention. John Ruskin, in *The Stones of Venice*, observed of the ancient Egyptian workmen that "though the manner of executing certain figures is always the same, the order of design is perpetually varied." To fully realize forms—and this includes the most conventional forms—involves a struggle, even if

the Egyptian artist or craftsman regarded that struggle as little more than the practiced attention of hand and eye to a particular task. The gradual evolution of sculptural forms—very slowly in ancient Egypt, much more rapidly in ancient Greece—shows how generations of artists grappled with the rival claims of authority and freedom as they resolved any number of representational, symbolic, and narrative problems. From the point of view of our experience of the artist's work, it hardly matters that the artists who labored in earlier centuries would rarely if ever have described their work in these terms.

Perhaps the easiest way to begin to think about the meaning and value of the arts is by remembering what attracted us to literature, music, and the visual arts in the first place, often when we were kids. Those experiences almost invariably had strong elements of fantasy, daydream, and even obsession. They took us out of ourselves; they felt irresponsible, irrepressible, liberating. The writer Alfred Kazin, who grew up in a family of Jewish immigrants in the Brownsville section

of Brooklyn in the 1920s, recalled his first visit to the Metropolitan Museum of Art as a teenager in a beautiful memoir, *A Walker in the City.* "I was flung spinning in a bewilderment of delight from the Greek discus-throwers to the Egyptians to the long rows of medieval knights to the breasts of Venus glistening in my eyes." Ralph Ellison, in the introduction to his collection of essays *Shadow and Act,* remembered the impact that jazz had on "the minds of the young" when he was coming of age in Oklahoma City. He saluted "the southwestern jazz of the thirties, that joint creation of artistically free and exuberantly creative adventurers, of artists who had stumbled upon the freedom lying within the restrictions of their musical tradition." Ellison and his friends were thrilled to be listening to musicians who were, as he later understood, "busy creating out of tradition, imagination and the sounds and emotions around them a freer, more complex and driving form of jazz."

We all know what Kazin and Ellison were talking about. We know what it means to be carried away by a book or a piece of music. Sometimes we actually say that we're lost in a book. I remember a summer vacation

during my teenage years when I was sitting in the back-yard reading Jane Austen, so immersed in the unfolding story that I could barely get up from my chair to eat lunch. And I remember the intoxicating, breakaway power of certain modern paintings—of Matisse's *Red Studio*, with that mysterious, all-enveloping hue, and each object drawn individually, distinctly. These early encounters—and I know many people have similar ones—are often experiences of besottedness. We're caught up, almost unthinkingly, in the astonishing generosity of the arts, in the plethora of images, sounds, rhythms, themes, atmospheres, characters, narratives, and motifs. In retrospect, we may be a little embarrassed by these experiences. We may also believe that the giddy irresponsibility of these earliest, imperishable encounters amounted to a sea change in our lives—expanding our imaginations, multiplying our possibilities. Ellison certainly felt that way. He said that the jazz musicians he got to know when he was a kid, through the freedom of their art, inspired him to become an artist.

But looking back on my early encounters with works of art, I realize that there was always a sense of

something strenuous and resistant mixed in with the overwhelming luxuriance. An experience that was initially about losing myself in the paradise of art was also, almost simultaneously, about finding myself in a world with its own coordinates, processes, and possibilities. The daydream was driven by a reasonableness, a delimitedness. Authority and freedom were both present. Reading Austen, I was conscious not only of the liveliness of her characters, the sharpness of her comedy, and the what-comes-next pull of her story. I was also conscious of the exquisite structuring of each novel's opening pages, the artfulness with which characters were introduced, and the elegance of the everything-wrapped-up-with-a-bow endings. As for Matisse, I didn't know how he arrived at the singular red that filled his canvas end to end. I still don't entirely understand his choice. And yet his outrageous transformation of an artist's studio into a flat, unified field impressed me with its inevitability. By cataloguing each of the variegated items in his studio, often with a precisely drawn outline, and then joining them all together with that bold, incisive hue, Matisse suggested that unity could transcend disparity. He was also, how-

ever radically, acknowledging an artist's obligations to the imperatives of his art: to the rectangle of the canvas and the balance of line and color. Few artists have embraced the struggle between authority and freedom as passionately as Matisse.

While there have been many periods when the arts inspired some sort of controversy, different times have different troubles. In our data- and metrics-obsessed era, the central problem is that the imaginative ground without which art cannot exist is under threat. The idea of the work of art as an imaginative achievement to which the audience freely responds is now too often replaced by the assumption that a work of art should promote a particular idea or ideology, or perform some clearly defined civic or community service. Instead of art-as-art, we have art as a comrade-in-arms to some supposedly more stable or socially significant aspect of the world. Now art is all too often hyphenated. We have art-and-society, art-and-money, art-and-education, art-and-tourism, art-and-politics, art-and-protest, art-and-fun. Race, gender, and sexual

orientation become decisive factors, often as a way of giving some readily comprehensible coordinates to the inherently uncategorizable nature of the artistic imagination. Given all the uncertainties that surround any creative endeavor, I can see why so many people want to link art to something else—something that can be more dependably defined. But all such efforts, however honorable, are stopgap measures, bound ultimately to fail, unless they are grounded in an insistence that the products of the imagination have their own laws and logic.

All too often we assume that the artistic act is essentially centrifugal—a statement beamed out to the world. I think it would be closer to the truth to describe the artistic act as centripetal—a dialogue between the artist and the tools of a particular trade. Such a dialogue has shaped everything from the anonymous Egyptian craftsman's carving in a Pharaoh's tomb to Mozart's operatic account of the Don Juan story, Wordsworth's reimagining of the poetic possibilities of the English language, and Mondrian's labors on his final, unfinished painting, *Victory Boogie-Woogie*. This dialogue is as essential to the popular arts as to any other kind of

art. Great performances of popular songs, generally designed to last only a few minutes, communicate soaring emotions with a telegraphic precision that depends on the close coordination of instrumental sound, vocal inflection, and verbal sense. All artists—the good along with the great, the ones who aim for the widest possible audience along with those who expect to speak to very few—know that the imaginative adventure, as profoundly personal as it is, must be set within the context of an ordering imagination which acknowledges the precedents and precepts of a community and a tradition. Private efforts become public experiences that can excite and inspire but also disquiet and disturb.

The arts are simultaneously dispassionate and impassioned. If this is a paradox, it also explains their undying fascination. A struggle or debate between authority and freedom is sunk deep in every significant work. As readers, listeners, and viewers, we unpack the struggle. We discern, even in ancient, anonymous works, different degrees of impact and intensity. What we regard as dutifully or dully academic or merely a copy is the work in which we miss the particularities of hand and mind. We register that absence, quite rightly

I believe, as an absence of freedom. What we are looking for—what we hunger for—are the forms and formulations that artists, writers, musicians, and all other creative spirits have forged from the struggle between authority and freedom. The more novels, paintings, or songs with which we're intimately acquainted, the more attuned we can be to how different artists assert their freedom. The artistic struggle is personal and impersonal and particular and universal. The work of art, with its freestanding power, is the resolution of that struggle.

I want us to release art from the stranglehold of relevance—from the insistence that works of art, whether classic or contemporary, are validated (or invalidated) by the extent to which they line up with (or fail to line up with) our current social and political concerns. I want to convince a public inclined to look first for relevance that art's relevance has everything to do with what many regard as its irrelevance. What do I mean by this? It goes without saying that we want works of art to have meanings that resonate with us, our friends, and the wider world. We like a good story. We're eager to see interesting places, meet fascinating

characters, and hear unfamiliar, provocative sounds. We're excited by polemics and reportage, whether historical or contemporary. But what holds together all the disparate elements in any work of art, at least any that endures, are the novelist's mastery of prose and storytelling, the composer's or musician's mastery of harmony and melody, and the painter's mastery of color and composition. The artistry with which the elements are united is what makes the subject matter really count. That's why it's so important to listen to what artists themselves have to say about their working methods. The arts help to shape our world, and they do so precisely because they have their own shape, dynamic, and vantage point. That shape, dynamic, and vantage point have everything to do with how creative spirits choose to negotiate the rival claims of authority and freedom.

In the chapters that follow I want to begin by emphasizing the systems and practices that provide the foundation for the authority of any artistic pursuit. I will discuss the sense of vocation that gives artists their purpose and focus—and acts as a bulwark against the unwanted pressures of the wider world. There will be

much more to say about authority and freedom, both what I see as the philosophic underpinnings of this fundamental creative process and how it operates in the work of particular artists. Finally, I must speak about what I regard as the mistaken belief that artists who fail to respond to their social, economic, or political circumstances are turning their backs on the world. So far as I am concerned, no artist who has wholeheartedly embraced an artistic tradition and found something personal within that tradition can be condemned to irrelevance. The artist who has struggled with authority and freedom has confronted one of the most basic human predicaments.

2 PLANNING AND MAKING

We know the scenarios that Hollywood favors when attempting to represent the creative life: the banging away on the typewriter or the piano; the painter's canvas tossed angrily aside; the ashtray full of cigarettes; the personal hygiene shot to hell. The artist, whether a shouter, a malingerer, a danger to friends and lovers, or a candidate for a suicide watch, is almost invariably shown doing something, not making something. Even when the performance is as intelligent as Kirk Douglas's as Van Gogh in Vincente Minnelli's *Lust for Life*, it's all too easy to laugh at the dramatization of the artist's life. The problem is that the act of creation, whether a

painter grappling with a rectangle of canvas or a novelist dramatizing the life of New York or Los Angeles, has almost nothing in common with the actions we expect from men and women who cut a figure in the world. The creative spirit knows that all action—the thinking, the planning, and the execution—must be submerged in the finished work of art. Only then is the true nature of the artist revealed.

Artists aren't the only people who make things. You can make a cake. You can make a law. You can make love. But I think it's worth pointing out that since ancient times philosophers who have taken an interest in the arts have argued for a distinction between *making* (which can describe a creative process) and *doing* (which covers a much wider range of actions and activities). Artists make, politicians do. We're underscoring this point when we refer to movie directors as filmmakers and musicians as music makers; a documentary about the modern dance choreographer Paul Taylor is entitled *Dancemaker*. To be an artist is to make things. Of course making things involves dealing with realities and practicalities. But the artist's realities and practicalities are unreal and impractical, at least by the stan-

dards of the workaday world. (That's what distinguishes a lawmaker from a filmmaker or a music maker.) Art is an abstraction of making—making turned in on itself. This is why the act of creation can be so powerful—and, sometimes, so bewildering.

For the artist it's never enough that the work is well made. The well-made work is the work that acknowledges the authority of a tradition and does nothing more. The artist must engage with the freedom that's possible within that tradition, so that making becomes an exploration of how things have been made in the past and involves some element of remaking—not replicating or reproducing but evaluating what has already been done and then making adjustments, whether large or small. We are captivated by the frankly experimental chiaroscuro brushwork that turns some of Rembrandt's portraits into psychological explorations. We thrill to Walt Whitman's long lines and incantatory rhythms, which seem designed to embrace the totality of human experience in ways unknown in earlier poetry. In Mozart's piano concertos we may sense how he has expanded the older, more limited role of the soloist into a full-blown dramatic protagonist, thereby

remaking the relationship between the individual musician and the musicians who are gathered together in the orchestra. Rembrandt, Whitman, and Mozart are asserting the right to remake—and thereby feel free within—the authority of a tradition. These are traditions not of ideas but of things: paintings, poems, musical scores, performances. The artist can be a romantic, a fantasist, or a dreamer, but before everything else the artist must be a rationalist and a pragmatist. The job must get done.

There is no denying the materiality of the arts. As for art that does away with the object (Conceptual Art, Idea Art), isn't that just the exception that proves the rule? Because the arts occupy real space and real time, they can become, for those who fully embrace them, a bulwark against some of life's chaos. You can call this escapism, but to look at a painting, listen to a concerto, or read a book of poetry is also a way of taking a stand in the world. When challenged you may find it difficult to explain exactly where you're standing. That's because the materiality and the immateriality of the arts go hand in hand. Nothing but art operates in quite this way. Jean-Baptiste-Siméon Chardin, whose

still lifes and figure studies are among the supreme achievements of eighteenth-century European civilization, said, "Painting is an island whose shores I have skirted." He was describing a mystery, but the image he chose was extraordinarily—fittingly—concrete.

Writers, composers, choreographers, painters, and sculptors all aim to establish a solid foundation for their imaginative flights. An argument can be made that the wilder the flights the more solid the foundation needs to be. We believe in the unearthly fantasy of Bosch's *Garden of Earthly Delights* because of the graphic precision with which each element is realized. We grasp the fin de siècle France of Proust's *In Search of Lost Time* because the narrator's sense of time and space is plotted and elaborated with such lucidity; Proust's psychological arpeggios are rooted in his old-fashioned novelistic discipline. The character of a work of art has everything to do with the breadth and depth of the artist's engagement with the fundamentals—the principles, systems, and practices that artists depend on when putting together a work of art.

We may be reluctant, and not without reason, to wholeheartedly embrace the belief, held by Leonardo da Vinci and other artists of the Renaissance, that the arts and the sciences offer related if distinct ways of searching for the truth. But there is no denying that creative spirits in many times and places have insisted that their work depends on a practice every bit as disciplined as that of any scientist. In his book *The Classical Style*, the pianist Charles Rosen observed that "since the Renaissance at least, the arts have been conceived as ways of exploring the universe, as complementary to the sciences. To a certain extent, they create their own fields of research; their universe is the language they have shaped, whose nature and limits they explore, and in exploring, transform." Certainty means very different things for artists and scientists. But the certainty of a novelist, a poet, a painter, or a musician has its own kind of truth. "The laws of prosody and syntax," W. H. Auden observed of a poem, "are to it what the laws of physics and chemistry are to the physical universe." Artistic practices—the theories, systems, and procedures—are more closely related to ideas about truth and reality than many modernists and for-

malists are inclined to acknowledge. There is nothing accidental about the arts. Even the modern painters, composers, and choreographers who have made accident a part of their practice—the painter Ellsworth Kelly and choreographer Merce Cunningham come to mind—have done so purposefully, systematically. The concreteness—the pragmatism—of the arts is reflected in the treatises, notebooks, and sketchbooks that creative spirits have produced for centuries. Even artists who embrace chance talk about the *laws* of chance.

If you're going to make something, you'd better make sure you know how to proceed. Creative spirits in different times and places—the eleventh-century Chinese landscape painter, the medieval illuminator of manuscripts, the sixteenth-century Italian architect, and the late nineteenth-century novelist—have all been engaged in processes and procedures as rigorous, disciplined, and strenuous as those of many scientists. Nowhere is that discipline clearer than in the musical arts. Some kind of musical notation has been in use since ancient times. In the beginning, notation may have been little more than a way to record decisions that had originally been made instinctively, in the act

of singing or playing. Later, it became a system that composers depended on to order or discipline their ideas and emotions. Any system of notation reflects a desire to rationalize musical experience—to set even the most unruly musical impulses on a solid footing. Greek music was notated using letters and other symbols, employed in varying positions. The ancient Hebrew method of chanting the Torah and other texts, with phrasing indicated by a system of markings, is still used in synagogues around the world. In Europe, by somewhere around 1200, there were various systems developed that indicated melodic and rhythmic values. By the early seventeenth century, musical notation in Europe had evolved to something close to what we know today. The signs and symbols of musical notation, arguably as impersonal as the scientist's graphs and charts, can generate a range of sensations and emotions when they're realized in performance.

In the letters that Giuseppe Verdi sent to his collaborators in the nineteenth century he repeatedly insisted that the operatic drama must be built on a firm musical foundation. Writing to his librettists, he insisted on the ways that syllables and rhymes worked with musical

rhythms and sonorities. "You talk to me about 100 sylla-bles!!" he wrote in 1864 to Francesco Maria Piave, about a revision of *La forza del destino*. "And it's obvious that 100 syllables aren't enough when you take 25 to say the sun is setting!!!" Writing in 1870 to Antonio Ghislanzoni, the librettist for *Aida*, he urged him to "write seven-syllabled lines twice, then, if you have no objection, write some lines with masculine endings, which can be made to sound very effective in music sometimes." In 1865, consumed with preparations for a production of *Macbeth*, he pushed his collaborators to make sure that sight and sound were precisely coordinated with the underlying musical structure, which was, of course, also the dramatic structure. "You will see that in the ballet there is a certain amount of action which fits very well with the rest of the drama. The apparition of Hecate, Goddess of Night, is appropriate, because she interrupts all the witches' dances with her calm and severe adagio. I don't need to tell you that Hec-ate must never dance, but simply mime. Also, need-less to say, this adagio must be played by the *clarone* or bass clarinet (as is indicated), so that in unison with cello and bassoon it will produce a dark, hollow and

severe tone in keeping with the situation. Please also ask the conductor to keep an eye on the dance rehearsals from time to time, to ensure that the dances remain at the tempi I have asked for." A few weeks later he was writing about the last act of the opera. "You will laugh when you hear that, for the battle, I have written a fugue!!! I, who detest all that reeks of the academy. But I can assure you in this instance that particular form works well. The racing about of subjects and counter-subjects and the dissonant clashes can express the idea of battle very well. Ah, if you only had our trumpets, which sound so bright and full-toned. Your *trompettes à pistons* are neither one thing nor the other."

As to Verdi's instruction of singers, it's fascinating to hear him describing how musical emotion grows out of the science of music. "For singing," he wrote in 1871, "I should like the students to have a wide knowledge of music; exercises in voice production; very long courses in solfeggi, as in the past; exercises for singing and speaking with clear and perfect enunciation." But after all that had been done, the young singer had to be left to see where this education would lead. "I should like the young student, who by now should

have a strong knowledge of music and a well-trained voice, to sing, guided only by his own feelings. This will be singing, not of such-and-such a school, but of inspiration. The artist will be an individual. He will be himself, or, better still, he will be the character he has to represent in the opera." The singer's education prepared him for an exploration of his own feelings. The authority of music—the science of music—gave the singer the freedom to express a range of feelings. But it didn't stop there. Finally, the singer's feelings had to be reconciled with the particulars of the character that Verdi had written—with the specifics of the score and the libretto.

Among the visual arts, architecture is the closest in spirit to the sciences, especially where architecture and engineering meet. The architect depends on an authoritative group of precepts and principles to guide the workings of the individual imagination. Treatises on architecture, going back to Vitruvius's *Ten Books on Architecture,* the earliest that survives, mix practical information with artistic assertion; a modern commentator has called

Vitruvius's book, written somewhere between 30 and 20 BC, "a technical handbook with literary ambitions."

Vitruvius began with "The Education of the Architect," which "is born both of practice and of reasoning." The architect needed to know everything: literature, geometry, history, philosophy, music ("in order to have a grasp of canonical and mathematical relations"), medicine, and law ("especially the law governing those things necessary to buildings," so "that even before they begin their buildings they have taken care not to bequeath the patron a legacy of lawsuits along with their completed work"). Vitruvius covered everything from the way to construct a wall to the refinements of different styles of columns and types of temples. He stated, certainly not for the first time in human history, that the sense of beauty was related to the beauty of the human body. "Just as in the human body there is a harmonious quality of shapeliness expressed in terms of the cubit, foot, palm, digit, and other small units, so it is in completing works of architecture." When Leonardo drew his Vitruvian man in 1492 or thereabouts, he based it on the description of the male body's proportions in the third chapter of *On Architecture*. There

was a connection between the science of anatomy and the science of beauty.

In his notebooks, Leonardo ranged from the natural sciences to architecture and engineering as he built the foundation for his artistic flights. There's no question that Leonardo, avid as he was for all human knowledge, felt that he needed to know more than any painter actually needs to know. But you find that same yearning to establish a firm foundation for one's imaginative flights in the DNA of just about any man or woman who paints, writes, composes, or choreographs; they're establishing the principles and practices that set the stage for the assertion of freedom. Although Leonardo's notebooks are unique, the urge to produce sketchbooks, notebooks, manuals, and treatises of all kinds can be found among creative spirits of many different times and places. The earliest pattern book or copybook that may have survived is from Egypt in the second century BC; it consists of two papyrus fragments that include drawings of birds, a lion, and the sun god represented as a quadruped with the head of a falcon. Some three dozen pattern books or copybooks survive from between the tenth and the fifteenth centuries in Europe. Analo-

gies between the human figure and geometric forms turn up in Villard de Honnecourt's sketchbook, created more than two hundred years before Leonardo drew his Vitruvian man. Although Honnecourt was long presumed to have been an architect, we know nothing about him beyond the evidence of his album, and no one is sure about the function of this compilation of drawings that includes figures, animals, insects, narrative scenes, machinery, and architectural plans and elevations.

From Tuscany, around 1175, there is a group of sheets with designs for an entire ornamental alphabet; some of the letters incorporate a figure or an animal. Other manuals mingle studies of figures and animals with all sorts of decorative designs. Most of these gatherings are fragmentary. In many cases it isn't clear where they were done or exactly why. They document the look of the natural world, with an emphasis on fauna rather than flora. They depict certain aspects of the man-made world, especially architectural designs, whether proposed or completed isn't always clear. And they define, to one degree or another, a set of stylistic practices and norms. Even in the fragmentary forms in which they have come down to us, they present an anatomy or tax-

onomy of the visual imagination of Western Europe from the Middle Ages to the early Renaissance. Here are the beginnings of a science of the visual arts—and also some sources of art's disciplined imaginative play.

If we turn to Asia, we find that in the same years when the first pattern books or copybooks were being put together in Europe, artists were offering not only similar books, but also expansive texts on the nature of painting. Here is Han Cho, around 1100, in a text "Concerning Defects in the Use of Brush and Ink": "Now, if you rely too much on ink, you destroy the real substance of things and injure the brushwork, as well as muddy the painting. But where the use of ink is excessively feeble, the spirit becomes timid and weak. Both excess and insufficiency are defects." When Kuo Hsi, writing sometime in the eleventh century, described the different varieties of mountains, he was cataloguing an aspect of the natural world. He was pushing younger painters to embrace the pictorial possibilities. "A mountain has the significance of a major object," he began. "Its form may rear up, may be arrogantly aloof. It may be lofty and broad, may sprawl. It may spread vast and extensive, may be solid and bulky. It may be heroic

and martial, may be sacred or awe-inspiring. It may glare down or hold court to its environment. It may be capped with further peaks or ride upon lesser slopes. It may have others which lean upon it in front or depend upon it in the rear. It may seem to gaze down from its eminence and survey the ground below. It may seem to wander down to direct its surroundings. Such are the major formations of mountains." Kuo Hsi offered an almost scientific presentation of the metaphoric and symbolic possibilities of mountainous terrain.

Of course there are risks involved in pressing too hard on analogies between science and the various arts. Henry James, in the essay "The Art of Fiction," first published in 1884, emphasized those risks. It was his feeling that visual artists operated on a much more secure foundation than literary ones. "If there are exact sciences, there are also exact arts," he observed, and proceeded to speak of the "definite" character of "the grammar of painting." As for the writer, he believed that he "would be obliged to say to his pupil much more than the [painter to his pupil], 'Ah, well, you must

do it as you can!'" The principles that might guide the novelist, he said, "are suggestive, they are even inspiring, but they are not exact, though they are doubtless as much so as the case admits." There was no question in James's mind that, at least when it came to the study of people, places, and things that absorbed the novelist, "the measure of reality is very difficult to fix."

Some of James's comments about the relationship between science and the various arts in "The Art of Fiction" were a response to a pamphlet by Walter Besant. In his efforts to demonstrate that he took the art of the novel even more seriously than the altogether serious Besant, he may at certain moments have protested too much. James, who quite understandably wanted to emphasize the almost limitless possibilities open to the novelist, complained that Besant was all too eager to say "what sort of an affair the good novel will be." But even as James was shying away from the scientific analogy, he was speaking about his work in some of the ways that scientists speak about theirs. "Art lives upon discussion," he wrote, "upon experiment, upon curiosity, upon variety of attempt, upon the exchange of views and the comparison of standpoints; and there

is a presumption that those times when no one has anything particular to say about it, and has no reason to give for practice or preference, though they may be times of honour, are not times of development—are times, possibly even, a little of dullness." Again, he spoke of "the power to guess the unseen from the seen, to trace the implication of things, to judge the whole piece by the pattern, the condition of feeling life in general so completely that you are well on your way to knowing any particular corner of it." His metaphors sometimes assumed close observation of the natural world—which of course is the scientist's purview. Experience, he wrote, is "a kind of huge spider-web of the finest silken threads suspended in the chamber of consciousness, and catching every air-borne particle in its tissue."

The notebooks that James kept throughout his writing life—they only began to be published in the 1940s—reflect the extraordinary deliberateness with which he constructed his fictions. Some will say, and not without reason, that this is by no means typical of how novelists proceed. Indeed, E. M. Forster, in his own way a meticulous craftsman, once observed that

the artistry the novelist was called upon to exercise was "not as high as Henry James thinks." But the processes that are on display in James's notebooks, while perhaps more self-conscious than those of many novelists, nonetheless tell us a great deal about the kind of thinking—deliberate, systematic, incremental—that writers share with scientists. At various points in the notebooks there are lists of names, which James discovered in the newspapers or heard as he circulated in London or Paris and thought might be useful in his fiction. Here is one list from 1879, when he was working on *The Portrait of a Lady*. "*Names*. Osmond—Rosier—Mr. and Mrs. Match—Name for husband in *P. of L.*: Gilbert Osmond—Raymond Gyves—Mrs. Gift—Names in *Times:* Lucky Da Costa—Names in Knightsbridge: Tagus Shout—Other names: Couch—Bonnycastle—Theory—Cridge—Arrant—Mrs. Tippet—Noad." Working on *The Princess Casamassima,* a novel in which he turned from his abiding themes among the middle and upper classes to subjects taken from the working classes, James noted phrases he had heard while out and about. "Phrases, of the people. . . . 'that takes the gilt off, you know.' . . . a young man, of his *patron,* in a

shop ... 'he cuts it very fine.' ... "Ere today, somewhere else tomorrow: that's *'is* motto.'"

James jotted down stories, anecdotes, and vagrant thoughts that struck him as having narrative possibilities. These could be quite brief, as when he described "a situation, or incident, in an alternation of letters, written from an aristocratic, and a democratic, point of view;—both enlightened and sincere." From this kernel emerged a long epistolary story, "The Point of View." Other entries in the notebooks were based on the gossip of friends and acquaintances. James was hungry for everything he could find out about the troubles in a family or the dynamics between a husband and a wife or a parent and a child. He was a man doing his research, gathering data. In 1884, at the home of Mrs. Tennant, a friend of Flaubert's, he heard of a young Lord Stafford who had "been for years in love with Lady Grosvenor whom he knew before her marriage to Lord G"—another young man. With no hope of marrying her, and under pressure from his family, Lord Stafford offered "his hand to a young, charming, innocent girl, the daughter of Lord Rosslyn." But suddenly Lord Grosvenor died and his wife, so James wrote,

"becomes free." This struck James as having many possibilities. He wondered if Lord Stafford might call off his engagement and then, "after a decent interval—present himself to Lady G." This seemed dishonorable. The honorable thing would be to go ahead with the marriage that was already planned. Contemplating all of this, James found himself fascinated. What should Lord Stafford do? "The situation might make, as I say, a story, capable of several different turns, according to the character of the actors."

James was aware that many of the great novelists didn't proceed with his kind of punctiliousness. In "The Art of Fiction," before attempting to make any generalizations about the nature of the novel, he observed that "it would take much more courage than I possess to intimate that the form of the novel, as Dickens and Thackeray (for instance) saw it had any taint of incompleteness." Be that as it may, for our purposes I don't think there is any question that in all the arts there has always been a desire—no: a necessity—to establish some solid basis on which to proceed. This is the planning that goes into the making. Verdi's determination to build the drama on a firm foundation of rhythm

and sound; Vitruvius's instructions for the education of the architect; the copybook of the ancient Egyptian artist; the Chinese painter's instructions about the art of landscape; James's construction of the art of fiction from names, turns of phrase, and anecdotes: all of this reflects the inner necessity of the arts, the creative spirit's determination to make something that can stand on its own, precisely because it's rooted in rules, systems, and processes that are immune to the vagaries of politics, society, and day-to-day life. It's the discipline of art that frees the artist to go public with the most private thoughts and feelings. No matter how the world encroaches on the artist, the artist in the act of creation must stand firm in the knowledge that art has its own laws and logic. These are the fundamentals of the creative vocation.

3 THE IDEA OF VOCATION

Vocation was originally a religious term. The word comes from the Latin *vocatio*, which means a summons, a call. To be a priest, a monk, or a nun is to accept a calling—a vocation. The sense of an imperative—of an activity that's a necessity, an inevitability—remains very much part of the meaning of the word today. A creative vocation isn't a job. It's a calling, even if for most modern artists the summons is an inner necessity, not the call of some divine figure or force. Even an artist as determinedly secular as Picasso saw echoes of religious vocation in his experience as an artist. When his mistress Françoise Gilot, wondering at his concen-

tration and stamina, asked him if when he was painting "it didn't tire him to stand so long in one spot," this was his response: "No. That's why painters live so long. While I work I leave my body outside the door, the way Moslems take off their shoes before entering the mosque." For creative spirits the studio or stage—or wherever they do their work—is a place apart. They may recoil from describing this as a sacred space, but there's no question that these spaces have a special significance.

Since ancient times, artists and their admirers have speculated about the supernatural forces that might fuel the creative act. Homer began the *Iliad* by invoking a goddess and the *Odyssey* by invoking a muse, and in the sixteenth century, Giorgio Vasari, by many estimates the first historian of art, spoke of Michelangelo's "divine" powers. In more recent times, perhaps beginning with Mallarmé's final poem, "A Throw of the Dice Will Never Abolish Chance," the uncertainty of chance has been invoked as a key element in the creative act: a deus ex machina for a skeptical age. Marcel Duchamp, the most philosophic of the Dadaist troublemakers of the early twentieth century, gave chance a

mystical spin when he observed that "the artist acts like a mediumistic being who, from the labyrinth beyond time and space, seeks his way out to a clearing." Whatever the mechanism—whether the intervention of the gods, the inspiration of a muse, a toss of the dice, or the actions of a medium—we keep coming back to the relationship between agency and art. There are certain modernists—Gertrude Stein with her incantatory word repetitions or John Cage with his silent piano piece, *4'33"*—who have left their admirers little alternative but to conclude that agency is its own justification. If you do something you've made something. However neat that equation—act equals art—the act won't count for much unless raw materials (words, sounds, sights) have been turned into works of art capable of commanding attention. It's the artist's dedication to the materials that gives the work its urgency, but it's an urgency that has a complex, ambiguous relationship with the artist's own time and place. That's why the spiritual or mystical metaphors make some sense.

In her essays, Katherine Anne Porter has many striking things to say about the nature of artistic vocation. For Porter, who practiced and perfected the art of fic-

tion through the Great Depression and World War II, life was a bewildering onslaught that could only be tamed through the artist's total commitment to an art form. A vocation was an anchor, the certainty that subdued life's uncertainties. In an essay about Virginia Woolf, Porter commented on the openness and originality of Woolf's thinking and writing. "She was full of secular intelligence primed with the profane virtues, with her love not only of the world of all the arts created by the human imagination, but a love of life itself and of daily living, a spirit at once gay and severe, exacting and generous, a born artist and a sober craftsman; and she had no plan whatever for her personal salvation; or the personal salvation even of someone else; brought no doctrine; no dogma. Life, the life of this world, here and now, was a great mystery, no one could fathom it; and death was the end. In short, she was what the true believers always have called a heretic." So how, given the openness of her experience, did Woolf achieve the astonishing profundity and lucidity of her art? The answer, so far as Porter was concerned, was through her sense of vocation. "She wasn't even a heretic," Porter pursued, "she simply lived outside

of dogmatic belief. She lived in the naturalness of her vocation. The world of the arts was her native territory; she ranged freely under her own sky, speaking her mother tongue fearlessly. She was at home in that place as much as anyone ever was." Porter says something very important here. "She lived in the naturalness of her vocation." Her vocation, her art, was her nature.

In 1950, the same year that she wrote about Woolf, Porter published a little essay about a French artist by the name of Pierre-Joseph Redouté, who was famous for his watercolors of flowers, especially roses, and his innovations in color printmaking. What fascinated Porter about Redouté, who was born in 1759 and died in 1840, was his ability to survive and pursue his art amid the astonishing political and social transformations that were reshaping France during his lifetime. It seemed that a person with a passionate attachment to a vocation would not—could not—be undone by the onslaught of events. Physically, Porter wrote, Redouté was an unprepossessing man. After his studies, his skill at painting flowers brought him into contact with members of the French royal family, some of whom took an interest in gardening and botany, and so he

found himself "in the center of the royal family, as private painting teacher to the Queen, later appointed as 'Designer of the Royal Academy of Sciences,' designer in Marie Antoinette's own Cabinet." Redouté, Porter observed, "seemed destined to go almost untouched by political disasters. . . . On the very eve of the revolution, he was called before the royal family in the Temple, to watch the unfolding of a particularly ephemeral cactus bloom, and to paint it at its several stages." Then the royal family was no more, but Redouté went on, working under the National Convention and then for Josephine Bonaparte and teaching Empress Marie-Louise. Porter wouldn't have bothered with Redouté's story if she hadn't believed that it had some broader, almost allegorical significance. She was suggesting that artists, the major ones as much as the minor ones like Redouté, must remain true to their work no matter what's going on around them.

Porter described Redouté as among "that huge company of men living in the tranced reality of science and art." For Porter that tranced reality—that different reality, the reality of art—wasn't a bad thing. "His life had classical shape and symmetry." He was

gifted, he worked hard, and "on the day of his death he received a student for a lesson. The student brought him a lily, and he died holding it." Porter's point was that the engagement with art gave Redouté a steadiness and a sense of purpose that could hold its own even against the upheavals of late eighteenth- and early nineteenth-century Europe. What interested Porter was the value of artistic vocation not only as a means of survival but, more fundamentally, as a way of life. The world of the arts was, as she put it about Woolf, the artist's "native territory." As for Redouté, he managed to navigate a perilous time by living in a "tranced reality." This "native territory" or "tranced reality" is the artistic vocation. Like the scientific vocation, the artistic vocation is a way of seeing and knowing the world. When passionately embraced, it eludes all labels. Many believe that a scientist's work should be insulated from social, economic, and political pressures. I certainly do. Shouldn't the same go for the work of a novelist, a painter, or a composer?

Although an artistic vocation may appear very different in different times and places, I think there is some

fundamental consistency about the act of creation, whether embraced by an eleventh-century Chinese painter or a nineteenth-century novelist. The nature of authority and freedom and the degree to which an artist sees limitations and possibilities will shift, sometimes dramatically, but the dynamic is always there. All too often we minimize the role of the independent imagination in the anonymous achievements of earlier epochs. But we also tend to overlook the essential part that disciplined craftsmanship plays in the work of nineteenth-, twentieth-, and twenty-first-century artists. Even Marcel Duchamp, the ultimate renegade of modern art, was a meticulous craftsman.

There is a long line of students of medieval art, from John Ruskin and William Morris in the nineteenth century to Meyer Schapiro in the twentieth century, who have insisted that the individual imagination can assert itself even in a period when stylistic and iconographic principles appear inflexible. Ruskin, looking at the masterworks of medieval architecture created by architects and carvers whose names are almost entirely unknown, found himself speculating on the imagination of what he called "the Gothic character," "the Gothic builders," and "the Gothic workman." In *The Stones of Venice,*

published in the early 1850s, Ruskin argued that in the Gothic period the workman was not "utterly enslaved," not forced, as he believed workers had been in ancient Greece or Rome, to reproduce by rote the same forms of capitals, columns, and entablatures. That, he argued, had been a form of "degradation." I don't think Ruskin was right about ancient Greece. The classicism of the classical world was never entirely homogeneous. But he was right to see that the Gothic style encouraged prolixity and variety. A basic Gothic form such as the pointed arch was open to a near infinity of variations, which were formulated through the more or less skilled labor of the individual workman. The act of creation was exercised in endlessly various ways. Ruskin was moved by the workmen's fascination with "Naturalism itself; I mean their peculiar fondness for the forms of Vegetation. . . . To the Gothic workman the living foliage became a subject of intense affection, and he struggled to render all its characters with as much accuracy as was compatible with the laws of his design and the nature of his material, not infrequently tempted in his enthusiasm to transgress the one and disguise the other." Ruskin focused on the complex and

compelling character of the act of creation, no matter who the creative individual might be. "Every discriminating and delicate touch of the chisel," he wrote, "as it rounds the petal or guides the branch, is a prophecy of the development of the entire body of the natural sciences."

For William Morris, who was very much a disciple of Ruskin's, the process of making a thing could not fail to be a creative act. "Art is man's expression of his joy in labour," he asserted. "The pleasure which ought to go with the making of every piece of handicraft has for its basis the keen interest which every healthy man takes in healthy life, and is compounded, it seems to me, chiefly of three elements; variety, hope of creation, and the self-respect which comes of a sense of usefulness; to which must be added that mysterious bodily pleasure which goes with the deft exercise of the bodily powers." Morris argued that in the guilds of the Middle Ages, "the unit of labour was an intelligent man. Under this system of handiwork no great pressure of speed was upon a man's work, but he was allowed to carry it through leisurely and thoughtfully; it used the whole of a man for the production of a piece of goods,

and not small portions of many men; it developed the workman's whole intelligence according to his capacity, instead of concentrating his energy on one-sided dealing with a trifling piece of work; in short, it did not submit the hand and soul of the workman to the necessities of the competitive market, but allowed them freedom for due human development." There is a political or social analysis of the nature of art to be found here. But there's also what might be called a politics of art itself. Labor, leisure, and thought come together to give the act of creation its freestanding value. For Morris this arrangement makes for much more than the production of attractive utilitarian objects; it's nothing less than the soil from which all art emerges.

I see echoes of Ruskin's and Morris's ideas something like a hundred years later, in an essay by the great art historian Meyer Schapiro entitled "On the Aesthetic Attitude in Romanesque Art." Schapiro insisted that the artists of the Middle Ages, whom many historians believed were almost entirely constrained by generally agreed-upon social, religious, and political values, actually made some highly personal and even idiosyncratic choices of subject and interpretation. Schapiro

wanted to "show that by the eleventh and twelfth centuries there had emerged in western Europe within church art a new sphere of artistic creation without religious content and imbued with values of spontaneity, individual fantasy, delight in color and movement, and the expression of feeling that anticipate modern art." One of Schapiro's central arguments was that there was much in Romanesque architectural sculpture that was so free-spirited and thematically independent that it actually offended some pious observers; there was already an artistic vocation that was putting pressure on the religious vocation. He quoted a critique by Saint Bernard of the art produced in the famous Abbey of Cluny. Looking at some recent stone carvings, Bernard questioned the purpose of "those ridiculous monsters" with their "marvelous and deformed beauty." He wondered about the justification for "those unclean apes, those fierce lions, those monstrous centaurs, those half-men, those striped tigers, those fighting knights, those hunters winding their horns." Schapiro thought that what bothered Bernard were "profane images of an unbridled, often irrational fantasy, themes of force in which he admits only a satisfaction of idle curiosity."

Schapiro argued that the theological systems of the early Middle Ages, rigid as some may have been, left room for the individual twists and turns of the creative spirit. Around 1175, a monk of Durham offered an enthusiastic description of the decorated textiles in which the remains of Saint Cuthbert were wrapped. "He admires," Schapiro wrote, "the ornament, the animal images, the colors, and the workmanship, even the texture of the materials, for their own sake, without inquiring into their possible symbolism; they are splendid artistically and therefore worth this extended notice." Schapiro cited a poem in which a monk praised

... the church's splendor;
The pomp of beauty glistens throughout the golden
 ceilings;
Metallic shell, gemmed fabric, inspiring wonder.

In these observations by religious men of the eleventh and twelfth centuries, Schapiro saw a very old recognition of the value of free imaginative play. Besides the religious function of a work of art or craft, there was also the value of the thing itself.

. . .

The novelist and short story writer Flannery O'Connor made a case for the singularity of the creative act in a letter she wrote to a friend, Father James McCown, in 1956. The subject was a work of fiction that O'Connor didn't like at all, although her friend apparently imagined that as a serious Catholic she would find its moral appealing. O'Connor explained to McCown that the book "is just propaganda and its being propaganda for the side of the angels only makes it worse. The novel is an art form and when you use it for anything other than art, you pervert it." She went on to say that "art is wholly concerned with the good of that which is made; it has no utilitarian end. If you do manage to use it successfully for social, religious, or other purposes, it is because you make it art first." O'Connor's statement deserves to be underlined: "You make it art first." She didn't leave it at that. "You don't dream up a form and put the truth in it," she argued around the same time. "The truth creates its own form. Form is necessity in the work of art." We might expect to hear an abstract painter say something like this. O'Connor's insistence on the autonomy of art is all the more remarkable because it comes from a writer who produced not brilliant wordplay but unsparing studies of the human

condition. Perhaps only a formalist could have seen the savagery of her contemporaries with as much clarity as O'Connor. "Vocation implies limitation," she wrote in 1957, "but few people realize it who don't actually practice an art."

Nobody would deny that a painter's painter or a poet's poet—Giorgio Morandi with his somber arrangements of vases, bottles, and boxes or Wallace Stevens with his exquisite verbal enigmas—has embraced a vocation. But it's all too easy to regard a vocation as something insular, best left to artists who are temperamentally and philosophically reclusive. There's a tendency to imagine that the greatest artists are the ones who grapple with the biggest philosophic and moral questions; Harold Bloom, a critic who was fascinated by titanic creative struggles, wrote a book entitled *Shakespeare: The Invention of the Human.* I think we are all too quick to imagine that the figures we regard as giants in the arts—Michelangelo, Shakespeare, Rembrandt, Beethoven, Wagner, George Eliot, or Tolstoy—couldn't possibly accept (much less embrace) the limits that a vocation imposes on an artist. There may be creative figures who rethink or even reimagine the nature

of vocation. But in the end there's not an artist who has anything to work with but the basics. That includes the artists who have most profoundly affected the social, political, and moral life of their time. It's worth taking a closer look at a couple of cases. No painting has become more of a symbol of the nightmare of modern warfare than Picasso's *Guernica.* No singer embraced the liberating hopes of the 1960s and 1970s with more eloquence than Aretha Franklin. But their work, even if made in direct response to a contemporary political or social development, was shaped by their devotion to the tools of their trade.

Picasso's *Guernica,* the twenty-five-and-a-half-foot-long mural painted for the Spanish Pavilion at the 1937 World Fair in Paris weeks after the Nazis bombarded and laid waste to a Basque town, is a lamentation. Although created before the London Blitz, the extermination of six million Jews, and the Allied attacks on Dresden and Hiroshima and Nagasaki, this mural in black and white and gray has for nearly a century been a symbol of the unspeakable cruelty that human beings are capable of inflicting on other human beings. If ever there was a work of art that seemed to emerge directly

from the social and political conflicts of the artist's time and place, that work is *Guernica*. But the story is much more complicated. In January 1937, Picasso accepted the commission to create a long, horizontal mural for a space on the ground floor of the Spanish Pavilion. With the help of his partner at the time, the photographer Dora Maar, he found a new studio in Paris, at 7 rue des Grands-Augustins, that was large enough to accommodate the project on which he had now embarked. For a long time Picasso wasn't sure how he was going to fill this enormous canvas. His first thought was to create a monumental painting on the theme of the artist and his model, which had preoccupied him for years. It may be that his thinking was fueled by the building in which he found himself working. Balzac had used the ancient structure on the rue des Grands-Augustins in his story *The Unknown Masterpiece* as the studio of a friend of the great artist Frenhofer, who was obsessed with a painting of a woman on which he had been working for years; earlier in the decade, Picasso had made a series of prints for an edition of Balzac's story. There are a dozen drawings from April 18 and 19 in which Picasso considered this theme of the artist in his studio. The

artist stands at his easel, contemplating the reclining female model.

Aside from these drawings, it doesn't seem that Picasso had done much of anything about the vast mural by the end of April, although the Spanish Pavilion was scheduled to open in May. It was on April 26 that German planes bombarded the Basque town of Guernica. In the ensuing days the massacre was widely reported in the press; 1,645 people died and close to 900 were injured in an attack that had no military objective beyond bludgeoning the Basque population into submission. *L'Humanité* was the newspaper that Picasso generally read. On April 28 he found there the headline *"Mille bombes incendaires lancées par les avions de Hitler et de Mussolini."* There were photographs of the dead and a view of the devastation that had been wreaked on the entire town. Two days later, on May 1, Picasso made his first studies for the composition that would become *Guernica*. What he was contemplating wasn't a direct response to what had happened in Spain but a renewed exploration of themes that he had been pursuing for much of a decade if not for most of his life. In the five weeks that he worked on *Guernica*, he mingled

Christological elements with recollections of Greek mythology. He returned to an interest in Matthias Grünewald's sixteenth-century altarpiece of the Crucifixion, which he had first responded to in a group of drawings in 1932. He was emboldened by Grünewald's figure of Mary Magdalen—who is both saint and sinner, holy woman and whore—and by the terrifyingly twisted, clawlike hands that Grünewald gave to both Mary Magdalen and Christ himself. He cycled back to a fascination with the legend of the Minotaur, which he had contemplated in works of the 1920s and in one of his greatest prints, *Minotauromachy* (1935). Now he joined the images in *Minotauromachy* of two women looking out of a window and a girl holding a candle to create an indelible vision of a woman at a window holding aloft a lantern.

Before *Guernica* was a response to the catastrophic bombing of the Basque town in April 1937, it was a meditation on human chaos, confusion, and agony that drew together themes that had long preoccupied Picasso. Earlier in the year he had produced a mocking series of images of General Franco, who would soon enough be the master of a Fascist Spain. But Picasso's overtly

political and polemical images of Franco had no place in *Guernica*. Neither did the news photographs from Spain, however powerful they might be. What Picasso found himself thinking about as he contemplated the sufferings of the men and women of Guernica were images from Hellenistic sculpture and the work of neoclassical painters of the seventeenth and eighteenth centuries, including Nicolas Poussin, Guido Reni, and Jacques-Louis David. Picasso had been pursuing ideas about the distortion of the human body since he painted *Les Demoiselles d'Avignon* (1907) and *Ma Jolie* (1911–12). Even before that, during the Blue Period, he had reflected on the spectacle of death in his tribute to the suicide of a friend, Carlos Casagemas.

There is little of current events and the Spain of 1937 in Picasso's *Guernica*. The space of the painting is an enclosed space—the space that Picasso initially conceived when he thought his theme would be the artist in his studio. The lamp at the center of the painting can only be understood as a light in a ceiling; that, too, brings us back to the original studies. What had happened between Picasso's first thoughts and his final ones was that the nature of the studio had changed.

Instead of the setting for a confrontation between the artist and the model, it was now the staging ground for a threnody on themes of death and destruction. The bombs that rained down on the Basque town of Guernica were the match that lit the fuse. But the lamentation that is *Guernica* had been prepared long before. When speaking seven years later with a friend, the photographer Brassaï, Picasso said that "the Spanish like violence, cruelty, they like blood, like to see blood flow, stream—the blood of horses, the blood of bulls, the blood of men. Whether it's the 'Whites' or the 'Reds,' whether they're flaying priests or communists, there's always the same pleasure in seeing blood flow."

Guernica is almost universally accepted as an indictment of humanity's inhumanity. That wasn't necessarily the reaction when the painting was first shown in the Spanish Pavilion in the summer of 1937. The artist José María Ucelay, who was in charge of the Basque contribution to the pavilion, didn't like *Guernica* at all. He said, "It has no sense of composition, or for that matter anything . . . it's just seven by three meters of pornography, shitting on Guernica, on the Basque Country, on everything." The philosopher Paul Nizan, a man with

Communist affiliations, found it bourgeois, a product of the ivory tower. The English art historian Anthony Blunt, also reflecting the official Communist view, complained that *Guernica* "is not an act of public mourning, but the expression of a private brain-storm which gives no evidence that Picasso has realized the political significance of Guernica." Picasso hadn't provided the clear picture of what happened in Guernica that some hoped for. But for those who admired the mural, the key to its greatness was precisely Picasso's rejection of a journalistic or propagandistic approach. The English writer Myfanwy Piper, who published the avant-garde art magazine *Axis* in England in the 1930s, wrote that "least of all is it a 'Red Government' poster screaming horrors to a panic-stricken intelligentsia." It is "a great painting and not just a piece of sentimental political propaganda." The grandeur of *Guernica* has everything to do with Picasso's detachment from the particulars of time and place. *Guernica* hadn't emerged from the world but from the artist's studio—from the exigencies of the artist's vocation. André Malraux, long after his Marxist days were over, might have been describing *Guernica* when he wrote that artists' achievements arise

"from their conflict with the mature achievements of other artists; not from their own formless world, but from their struggle with the forms which others have imposed on life."

Some will say that I'm belaboring the obvious. All artists, whether visual, literary, or musical, depend on working methods that involve precedents and conventions. That's true. But too often now the actual nuts and bolts of the creative act are treated as technicalities, mechanical or even automatic processes needed to realize some predetermined objective or goal. Nothing could be further from the truth. What we are in danger of dismissing as the technicalities are not only the artist's essential materials—the language through which the artist speaks—but the intellectual and expressive capacities of that language.

What I am saying is as true for popular music as for any other form of artistic expression. The great popular performers depend on deep reservoirs of technique and artistry; their art has less to do with the pressures of the moment than with all that they've done to pre-

pare for that moment. Nowhere is this truer than with Aretha Franklin, who grew up singing gospel in her father's church in Detroit and recognized those experiences as the foundation for much of her greatest work. Writing in 1961, when her career as a singer of secular songs was only beginning, she said, "I don't think that in any manner I did the Lord a disservice when I made up my mind two years ago to switch over." Asked in an interview in 1968 about the gospel influence, she said, "Basically, yes, the feeling is still there and it will always be, more than likely. But if you really wanted to break it down, you could go back even further to more distant roots—if you wanted." Six years later, when asked about the trajectory of her career, this woman who didn't much like discussing her work said, "I did sing in the young people's choir in my father's church— I started there. And from there, here."

In 1972, Aretha organized two evenings at the New Temple Missionary Baptist Church in Los Angeles, where, with a large chorus behind her, she recorded what became the album of gospel songs *Amazing Grace*. Her father, the Reverend C. L. Franklin, who was in attendance the second night, said that she had never

left the church. Gospel was there in the rhythms and techniques that Aretha and her collaborators pursued even when performing her most secular songs. Church music's call and response and febrile dynamics were techniques that she incorporated in her hits of the late 1960s and early 1970s. The more you know about gospel music, the more you see that the performances by Aretha that have come to define a generation were nurtured by her training in the church. The bass guitarist Chuck Rainey, who worked with Franklin on many hits, said of the 1971 "Spanish Harlem" that it had a "cross between an eighth-note feel and a shuffle. That's the gospel, Pentecostal feel where you're really trying to nail what the groove is." Franklin's genius—in skyrocketing performances that we've come to associate with the sexual revolution, the women's movement, and the civil rights movement—was first and last a matter of craft. The accompanists she gathered together in the early 1970s—along with Rainey, the guitarist Cornell Dupree, and the drummer Bernard "Pretty" Purdie— all of them, according to Aaron Cohen in his book about the making of *Amazing Grace,* "shared early experiences in the black church." Cohen explained that two "key-

boardists on the *Young, Gifted and Black* album—[gospel musician James] Cleveland's protégé Billy Preston and Donny Hathaway—had also been immersed in similar religious backgrounds." What gave Franklin's hits the resilience that complicated their urgency was that background in gospel and spirituals, the syncopations and dynamics that she had grasped as a child. When Aretha sat down at the piano—on recordings, in performances—there was a primal excitement. This singer who could do anything with her voice was demonstrating the basics of her craft with a workmanlike simplicity.

In the movie that was filmed during those two nights at the church in Los Angeles but only finally released after Franklin's death, Aretha is the calm at the center of the storm. *Amazing Grace*, directed by Sydney Pollack, begins with panoramic shots of Los Angeles in 1972 and the crowd filling the New Temple Missionary Baptist Church. Watching this footage half a century after the event, you can feel the heat of the years around 1970. You sense the optimism of the civil rights movement in all the beautiful Black faces gathered in the church. But you also recognize the unease of those years, when

Martin Luther King was gone and America's cities had been overwhelmed by riots—and racism seemed as intractable as ever. Into this charged situation comes a woman who is one of the biggest pop stars in the world but has chosen to perform with an old family friend, James Cleveland, and a magnificent choir directed by a young, wiry, unstoppable protégé of Cleveland's by the name of Alexander Hamilton. Something great is happening, something not to be missed. On the second night, Mick Jagger is in the audience, a consummate performer there to witness one of the defining performances of the era. In the front row are Aretha's father and a close friend of his, the gospel singer Clara Ward.

Amid all this Franklin displays a preternatural calm. She begins the first night seated at the piano, her eyes sometimes closed, singing "Wholy Holy." As the choir spins and shouts under Hamilton's energetic direction, Aretha can be almost expressionless, waiting for the moment when she takes up a song. She doesn't rise to the occasion so much as she sinks deep into the music. The astronomical highs that she achieves along with the choir and the musicians are built on the strongest and most secure foundations. In the moments before and

after she sings, as she sits or stands, quiet, concentrated, she's entirely absorbed in her craft. No singer has ever made the time, the place, the moment more thrilling. But the look on her face is the look of the artist who is focused on the nitty-gritty of her art. The solitude of an artist at the height of her powers has probably never been clearer than in the footage of Aretha Franklin at Los Angeles's New Temple Missionary Baptist Church in 1972. All eyes are on her, but she is alone with her vocation.

4 PHILOSOPHICAL SPECULATIONS

Just about anything that's been felt or thought can fuel a work of art: hopes, dreams, passions, beliefs, principles, predilections, uncertainties, fears, even prejudices. There are many other areas of human experience and endeavor where these same forces are in play. But life in a civil society nearly always demands compromises and accommodations. We adjust our most ardent ideas and emotions as we reach for consensus. Creative spirits, although by no means immune to the social and political forces that shape their time, aren't consensus builders—at least not in any direct way. Because the work that artists do is detached from so much

of what we think of as ordinary human activity and action—because they are making things rather than doing things—they're able to reimagine our ideas and experiences in an intensified, concentrated, hyperbolic form. There's a sense in which all creative spirits are extremists. That helps explain why for centuries popes and princes were so interested in cultivating the work of painters, sculptors, authors, and composers. They recognized the unique, perhaps otherworldly impact of these achievements that stand apart from life's compromises, conflicts, and intrigues. A statue or poem honoring a god or a hero, precisely because it's immune to life's ordinary pressures, can have an impact unlike anything else on earth.

The arts have a paradoxical place in our world. They're essential because they stand apart. Whatever the artist's relations with patrons and public, the artist's primary relationship is with the tools and techniques of the trade. But that relationship, which some view as an escape from the pressures of daily life, has its own daunting challenges. The poet Paul Valéry, in his "Introduction to the Method of Leonardo da Vinci," surveyed the many challenges posed by what

he referred to as the artist's "conscious act of *construction*." He wondered how much of this he could explain to a person "who has never completed—be it but in a dream—the sketch for some project that he is free to abandon; who has never felt the sense of adventure in working on some composition which he knows finished when others only see it commencing; who has not known the enthusiasm that burns away a minute of his very self; or the vision of conception, the scruple, the cold breath of objection coming from within; and the struggle with alternative ideas when the strongest and most universal should naturally triumph over both what is normal and what is novel." All of the advances, retreats, hopes, and disappointments that Valéry described—and I'm only citing a fragment from a much longer passage—are inherent in the creative act.

The most refined or virtuosic achievements almost invariably turn out, upon close inspection, to be the product of the tough creative battles that the "conscious act of *construction*" demands. Mozart's delicacy and Jane Austen's comedy wouldn't hold us if there weren't something steely about their work. So what is the origin of their power? Nobody can deny that the artist's social and political experiences and reflections

are among the raw materials that Mozart mastered in *The Marriage of Figaro* and Austen in *Mansfield Park.* But the way that Mozart and Austen have shaped their experience reflects an artistic imperative, not a social or political idea or ideal. The arts, at least the greatest expressions of the arts, have often been seen as fundamentally conservative or radical or liberal in spirit, with the choice generally determined by the ideological inclinations of the person who is making the interpretation. All such efforts strike me as fundamentally mistaken. That's why attempts to identify the political or social values of Mozart or Austen always fail. Popes, princes, and presidents may turn a painting or a poem to their advantage. But the struggle between authority and freedom—and the artist's search for perfection or for anything else—is essentially shaped by the language of art, which is a language unto itself. We often find ourselves pressed to speak about art as conservative or radical or liberal, but these are rough metaphors for an experience that has an indissoluble life of its own. That is art's ultimate value, a value that is confoundingly difficult to think or speak about, precisely because there is no analogy. Art is simply what it is.

. . .

Authority and freedom, as artists engage with these elemental forces in different times and places, have a reality that isn't susceptible to any analytical language other than the language of art. But in order to understand how these forces come alive in the act of creation, we must look to the work that philosophers have done. The writings on authority and freedom by Hannah Arendt and Isaiah Berlin can help us understand the forces at play in works as varied as the illuminated manuscripts produced in the Middle Ages, the architectural projects that preoccupied Michelangelo in his later decades, and the almost two dozen piano concertos that Mozart produced. Berlin actually turned to the arts, especially to the musical arts, when attempting to explain his ideas about freedom.

Hannah Arendt devoted a long section of her book *Between Past and Future* to the idea of authority. Her central point was that authority does not inhere in particular people or things but in an ancient tradition that the living embrace. The derivation of *auctoritas*, she explained, is "from the verb *augere*, 'augment,' and

what authority or those in authority constantly augment is the foundation." Arendt's interest in this idea obviously had everything to do with the contrast she wanted to draw with totalitarianism. Authority, she pursued, "always demands obedience." But this is a form of obedience that "precludes the use of external means of coercion; where force is used, authority itself has failed." Authority, therefore, "implies an obedience in which men retain their freedom." Authority is somehow disinterested (in the original sense of the word, not *uninterested* but *impartially interested*). Authority is a hierarchy of values about which a group of people agree. To the extent that the individual freely accepts that authority, authority becomes an expression of the person's freedom. "The authoritarian relation between the one who commands and the one who obeys," she wrote, "rests neither on common reason nor on the power of the one who commands; what they have in common is the hierarchy itself, whose rightness and legitimacy both recognize and where both have their predetermined stable place."

Arendt observed—and this is interesting from our vantage point—that "all prototypes by which subse-

quent generations understood the content of authority were drawn from specifically unpolitical experiences, stemming either from the sphere of 'making' and the arts, where there must be experts and where fitness is the highest criterion, or from the private household community." Arendt's point about authority and the arts was that what is critical for artists is less their own inclinations, dispositions, gifts, or powers of persuasion than their willingness and ability to embody values and principles that predate them. These are the foundational values. For the ancient Romans, Arendt argued, "all authority derives from this foundation, binding every act back to the sacred beginning of Roman history, adding, as it were, to every single moment the whole weight of the past." This is very much the way authority works in the arts—in all the arts. Every effort to paint a picture, write a poem, or compose a piece of music is in some sense a recapitulation of a foundational act or acts. The fourteen lines of a sonnet, the capital that completes a column, and the three movements of a concerto represent not the achievement of any individual but the authority of a literary, artistic, or musical tradition.

. . .

Creative spirits know that authority implies order—and that without some sense of order art ceases to exist. Isaiah Berlin, in his book *Political Ideas in the Romantic Age,* had some important things to say about the relationship between freedom and order as they were articulated by thinkers from the ancient Greeks to the German idealists. He wrote about a tradition that associated personal freedom with the ability to live in harmony with some "general pattern and purpose." Artistic freedom always involves engaging with some idea of order, which becomes an authority that the artist understands and acknowledges but to which the artist doesn't necessarily entirely submit.

"Man is a rational being," Berlin wrote, "and to say this is to say that he is able to detect this general pattern and purpose and identify himself with them; his wishes are rational if they aspire after such self-identification, and irrational if they oppose it. To be free is to fulfil one's wishes; one can fulfil one's wishes only if one knows how to do so effectively, that is, if one understands the nature of the world in which

one lives; if this world has a pattern and a purpose, to ignore this central fact is to court disaster." So there is some connection between freedom and order—and authority. "To be free is to understand the universe," Berlin wrote. Isn't that what artists want? To understand the universe—or at least the universe of their chosen discipline. "The well-known Stoic argument that to understand and adapt oneself to nature is the truest freedom," so Berlin explained, "rests on the premise that nature or the cosmos possesses a pattern and a purpose; that human beings possess an inner light or reason which is that in them which seeks perfection by integrating itself as completely as possible with this cosmic pattern and purpose." Of course most artists aren't Stoics. But there are many ways to assert one's freedom in the face of a "cosmic pattern and purpose." For Christians, freedom can involve an almost complete submission to some divine order. For eighteenth- and nineteenth-century artists and intellectuals, freedom suggested a more dynamic resolution of a conflict between the thoughts and feelings of the individual and the order that's essential for some political, social, or artistic good. Only when artists have felt

free enough to absorb the patterns and purposes of a particular art form can they begin to assert their own freedom. Come to think of it, there is something fundamentally Stoic about the artistic personality. Artists, even the most rebellious, can't help but affirm an art form's essentials.

It's interesting that Isaiah Berlin, in a number of his discussions of freedom, turned to the experience of the classical musician. He imagined himself in the position of the performer. "The more precisely, fully and faithfully I translate the notes of the score into sound—the more I make myself the faithful, undeviating, almost impersonal vehicle of the pattern of the ideas, or the sounds (or whatever the general design and purpose of the score may be)—the more I realize my function as a musician, the more creative I am being, the more freely my capacities as a musician are allowed to develop, the more deeply I satisfy my craving to play." Berlin called this a paradox, because "only in so far as there is a law, a specific rule which in my activities I obey, can I be free." The performing arts offer many opportunities to push freedom very far. Interpretations, even in classical music, vary dramatically.

And there are musical and performing arts in which virtuosity involves a kind of anti-virtuosity. Some great popular singers don't have natural singing voices and some great Broadway dancers don't have conventional dancers' bodies. Jazz, both instrumental and vocal, is often grounded in a dazzlingly authoritative response to the relatively simple authority of a tune or a song. Of course the relationship between authority and freedom is in many respects simpler when we speak of the relationship between the musician and the musical score than when we speak of the relationship between, say, a composer and a musical form. But, broadly speaking, the same analogy holds. Freedom can only be achieved after certain constraints have been accepted.

I know there are those who argue that the relationship that an actor, a singer, or a dancer has with authority and freedom is entirely different from that of a writer, a composer, or a choreographer. There are no doubt distinctions to be made, but I'm not sure that the difference between what an actor and a playwright do is any greater than the difference between what a playwright and a painter do. There's a reason why performers are referred to as artists. They confront both

the authority of a text and the authority of a performing arts tradition. In so doing, they juggle challenges as daunting as—if not more daunting than—those many other artists face. Every performance of *King Lear* is an exploration of the possibilities of *King Lear,* much as every novel is an interpretation of the possibilities of the novel. For the actor, *King Lear* is an authority that permits certain freedoms—but not ones that deny or refute the authority of the text. To watch Laurence Olivier act in *Othello,* see Suzanne Farrell dance in Balanchine's *Symphony in C,* or hear Eleanor Steber sing Berlioz's *Les Nuits d'été* is to be in the presence of artists who have achieved some preternatural balance between authority and freedom. The performing arts, which are among the most ancient arts, have much to tell us about the artist's search for freedom.

There is much to be learned about the interaction between authority and freedom by examining the achievements of premodern cultures. Anybody who has looked at the evolution of the illuminated manuscript in the Middle Ages has seen the process at

work. There are very few visual forms that are ruled by a stricter authority than the page of a book. In the Romance languages it has been taken for granted that lines of text move horizontally from left to right. Since well before the Middle Ages, these lines have been organized in blocks of text on pages that include a margin that separates the text from the edge of the page. For something like a thousand years, the artists who illuminated manuscripts, in confronting these conventions, asserted their freedom to transform the character of the page.

Their innovations took many different forms. The illuminators enriched the margins of the page, conventionally an empty space, with figurative, vegetal, or abstract elements. Sometimes the marginal images were merely decorative; at other times they functioned, rather like visual footnotes or sidebars, as serious or comic commentaries on the text. Another convention that the illuminators liked to reimagine was the capital letter that opened a sentence or a block of text. They would enlarge or complicate that first letter, sometimes with a moral or a story in mind, sometimes with phantasmagorical results. The authority of the letter shape,

a relatively stable and conventional form, was used as the framework for tremendous improvisations. In a page from the Windmill Psalter, a giddily elaborate creation produced in England in the late thirteenth century, the letter E became the substructure on which the artist erected a representation of the Judgment of Solomon. The crossbar of the E is the staging ground for Solomon's palace, with the open space formed by the upper part of the E turned into a throne room of sorts. Just outside the enclosure defined by the E are the two mothers, the baby for which they compete, and a soldier. The lower half of the E, a space apart, is occupied by an angel holding a scroll. This scroll contains the completion of the word *Beatus,* which actually begins with the B that occupies the entirety of the previous page. In a conceit of *Alice in Wonderland* playfulness, the letter E, from which the angel emerges, contains the continuation of the word of which it's a part. If all these liberties aren't enough, the elaboration of the E inspires a botanical fantasy that sprouts from the edges of the block of text, filling the margins with a calligraphic garden.

In a page from the Turin-Milan Hours, produced

more than a century later (perhaps in The Hague, perhaps by Jan van Eyck), the imaginative play is less recklessly improvisational, but equally daring in its reconsideration of the fundamental discipline of the page. Once again the margin is conceived as a garden-like space; the initial D sprouts vines and leaves that wrap around the entire page, sometimes clinging close to the image or the text, sometimes reaching the outer edges of the page. This sheet contains four distinct forms of representation or narration. First there are the four lines of text, moving across the page in the conventional manner. Then there's the initial letter, a D, which doubles as an enclosure, a frame for a representation of God the Father. Above this, also entirely enclosed, in this instance by what amounts to a gold frame, is a picture within the page, a naturalistic scene of the birth of Saint John the Baptist. Then, at the bottom of the page, there's a landscape representing the Baptism of Christ. But here the picture isn't entirely enclosed: both the bottom and side edges are set off by the meandering vines, while the sky in the landscape doubles as the flat white page on which the lines of text are inscribed. The page supports multiple levels

of illusion, each an assertion of the artist's imaginative freedom within the constraints of the page: the framed picture of the birth; the landscape that merges with the page of text; the figure of God the Father within a letter of the text. And there is still more: the Holy Spirit, the dove, is included, moving beyond the letter D that encloses God the Father, across the flat white of the page, into the landscape below. The authority of the page, with its block of text and clear margins, is both respected and confounded. The freedom of the artist's imagination becomes a tonic, a reaffirmation of the fundamentals.

Some will say that what I'm describing is a formal process, pure and simple. But the testing of limits is hardly only a technical or formal matter. It's also an unfolding experience of the dynamic relationship between authority and freedom—an enactment, in a realm remote from our daily concerns, of the struggle of the individual for realization and individuation amid the constraints of a tradition and a group. The dramatic nature of the artist's interaction with earlier conventions has too rarely been seen as having an ethical or philosophical dimension. When Jean-Baptiste-Camille

Corot, in the nineteenth century, took his easel out to paint the sights of Rome, he began with a sense of the authority that Poussin, two hundred years earlier, had brought to the art of landscape. Corot was immersed in the seventeenth-century painter's achievement: his orderly development of landscape space; his gift for dramatically juxtaposing natural and man-made forms; his sensitivity to the spatial rhythms that create a mood consonant with the nobility of a subject. Corot, as he regarded the Rome immediately before his eyes, was engaging with the conventions that Poussin had developed, but he was engaging with them in a playful and liberating way, simultaneously saluting them and confounding them. Poussin's beautifully orderly world became a beautifully disorderly world. Corot used Poussin's classicizing landscape as a provocation for his own intricate constructions, which exaggerated, complicated, and inverted the earlier artist's spatial ideas in ways that sometimes went so far as to foreshadow the Cubist innovations of Braque and Picasso.

There is a tendency to imagine that the most radical breaks with authority involve the arts of the past

several hundred years. But this isn't true. Not only is freedom emboldened by authority—we see that in the evolution of the medieval manuscript—but the tension between freedom and authority has for centuries been the subject of strenuous and heated discussion in the arts. Perhaps nowhere have these arguments been joined more dramatically than in the debates about the architecture of Michelangelo, which began during his lifetime and continued for more than a century afterward. Even as Michelangelo, in the mid-sixteenth century, was being hailed by Vasari and others as a divinity whose achievement marked the climax of art in Europe, he was being criticized as a man whose penchant for excess, experimentation, and extremes called into question the fundamentals of the classical tradition to which he was devoted. Questions were raised about his style as a figure sculptor and painter, for he pursued what some saw as an exaggerated treatment of the human form, lending it an almost expressionist character. Even more questions were raised about his architecture, which some believed made a hash of the laws of classical architecture as they had been codified by Vitruvius.

Nowhere does Michelangelo's daring reimagining

of classical forms strike with more force and immediacy than in the vestibule of the Laurentian Library in Florence, which he began working on in the mid-1520s, when he was in his late forties. Everything about the room is disquieting: the proportions of the space, much taller than it is wide; the massive staircase that occupies much of the floor; the dark stone that makes the massive architectural elements feel so oppressive. Michelangelo's theme here might almost be horror vacui. The most immediately disquieting elements are the immense columns. You would expect them to rest on the floor and support the ceiling. Instead, they seem to float in space, their bases high off the ground and their bulk inserted into cutouts in the walls. If this isn't strange enough, below each column (though not actually attached to it) is a massive volute. These suggest brackets that might support the columns, although the columns are in fact set back from the volutes, which project out from the wall. This is only the beginning of the disturbing aspects of the vestibule. There are the elaborate window frames that frame only blank space. And then there's the staircase itself, which leads up to the library proper. This immense structure—almost

an abstract sculpture—consists of not one but three separate sets of stairs. They overwhelm the vestibule before resolving into a single flight of steps that takes visitors into the library. So why wasn't there just one flight of steps to begin with? There is no question that Michelangelo was aiming for what the art historian James Ackerman called "a strange, irrational quality, unique in the Renaissance." "Everywhere in the vestibule," Ackerman wrote, "Michelangelo's licentious use of classical vocabulary, obscuring the actual relationships of load and support, created paradoxes for his academic contemporaries."

The vestibule of the Laurentian Library was hardly the only place where Michelangelo shredded the traditional relationship between architectural elements, leaving some of his contemporaries deeply disturbed. He liked to take traditionally stable forms—the pediment is an example—and break up or at least interrupt their accepted shape. The most voluble of Michelangelo's critics in his own day was an architect and antiquarian by the name of Pirro Ligorio. He accused Michelangelo of "extravagant inventions" and "breaking into little pieces" what had been the coherence

of classical architecture as presented by Vitruvius. Michelangelo, Ligorio believed, cultivated fragments. For Ligorio, Michelangelo's freedom with classical precedent—floating a column many feet from the ground or splitting a pediment in two—resulted in something that was "dreadful to look at" and suggested "dream or fury" or even "madness." He was "bashing in the brains" of Vitruvius's orderly idea of architecture. Although Ligorio's responses were the most outspoken, the great architect Palladio also had doubts about the soundness of Michelangelo's work. Palladio worried about Michelangelo's habit of complicating forms by violating the integrity of a pediment or breaking up the strong upward flow of a column with "rings and garlands."

For the architectural theorists of Michelangelo's day—and for the classicists who criticized his work later on—the relationship of column, capital, and pediment was a matter of fixed expectations. If art was related to nature, it was related to a stable or even static idea of nature; there was an idea that architectural proportions were originally related to the ideal proportions of the human figure. To this ancient connection between

architecture and nature—to the authority of classical architectural thought—Michelangelo felt free to add a feeling for nature that was not static but fluid. James Ackerman put it this way: "His association of architecture to the human form was no longer a philosophical abstraction, a mathematical metaphor. By thinking of buildings as organisms, he changed the concept of architectural design from the static one produced by a system of predetermined proportions to a dynamic one in which members would be integrated by the suggestion of muscular power. In this way the action and reaction of structural forces in a building—which today we describe as tension, compression, stress, etc.,—could be interpreted in humanized terms." What upset Michelangelo's detractors probably as much as anything else was that this dynamic architecture was grounded in the authority of the classical forms, but now used with a freedom that seemed to risk anarchy.

What Michelangelo brought to architecture was not an incremental evolutionary process but an insistence on taking a particularly extreme position in the dialogue between authority and freedom. Although it's not clear what ancient Roman buildings Michelangelo

would have known—much that existed in Rome in his day is now gone—the sort of anti-Vitruvian play that he embraced certainly had some precedents in the ancient world. A century after him, even as many architects closed ranks and reaffirmed the limpid authority of classicism, one of the greatest architects of seventeenth-century Rome, Francesco Borromini, built on Michelangelo's daring critique of Vitruvius, adding elements of wit and caprice. What in Michelangelo had been saturnine became sensuous in Borromini.

The freedom that the artist asserts is not necessarily a threat to authority; freedom and authority are also partners. In the twenty-three piano concertos that Mozart composed during his brief life, the authority of the concerto was solidified and concentrated, even as Mozart asserted a vast range of freedoms within that authority. The concerto originated a generation and more before Mozart, in the Baroque gatherings of musicians, where the sound of the ensemble was complicated by the individual voices of various instruments as they took solo roles. In Vivaldi and Bach we

see the beginnings of the basic situation that we know in the concerto from Haydn and Mozart to the present, where the drama is focused on the interaction between the individual voice of the soloist and the communal voice of the orchestra. Almost everybody relates Mozart's mastery of the concerto to his unparalleled grasp of operatic dynamics; the solo instrument, like the singer, is juxtaposed to the mass of the orchestra. Charles Rosen, in *The Classical Style*, emphasized Mozart's command of "long range movement" and his ability "to treat a tonality as a mass, a large area of energy which can encompass and resolve the most contradictory opposing forces."

A great many possibilities were open to Mozart as he worked the soloist against the orchestra in the three movements (another form of authority) that comprise each of his piano concertos. "The most important fact about concerto form," Rosen wrote, "is that the audience waits for the soloist to enter, and when he stops playing they wait for him to begin again." But when does the composer choose to make people wait and when does he satisfy their hunger for the soloist? Mozart avoids this initial waiting period in the Piano

Concerto no. 9 in E-flat Major, K. 271, where the piano comes in at the beginning, playing with the orchestra for the first measures, but then receding for a time. Generally, the orchestra introduces at the outset a number of elements to which the piano, when eventually it enters the fray, responds in a variety of ways. The pianist can play alone for a time, or plunge almost immediately into a collaboration with the orchestra, or pick up in part or in whole the themes that the orchestra has presented. But it's not only a matter of the one against the many, for the many is made up of groups of musicians (string, wind, brass, and percussion, as well as particular string, wind, and brass instruments), and some of them make themselves known as individuals. At times it seems as if the piano is developing a special relationship with an instrument in the orchestra.

It's important to remember that the competition between freedom and authority is not necessarily an evolutionary progress; often it's a cyclical process. As much as creative spirits will play fast and loose with forms of authority, they're also free to reassert older conventions—or at least their own earlier view of the conventions. In the case of Mozart's piano concertos,

some have seen his final concertos as a return to a more cut-and-dried—simplified—acceptance of the fundamentals of the form. The intricate play between the soloist and individual instruments that he had pursued in the mid-1780s may have given way to a more elemental interaction between soloist and orchestra. Mozart's final piano concerto, No. 27 in B-flat Major, K. 595, has two movements—the second and third—that begin with the piano alone. Here the piano can feel solitary, by turns solemn and playful. Rosen described not a retreat into simplicity but a new kind of freedom in "the sensation of an inexhaustible and continuous melodic line, somehow both seamless and yet clearly articulated." Arthur Hutchings, in his book on the piano concertos, saw in No. 27 "an economy and restraint that make it seem confidential between composer and listener." The reassertion of older forms of authority can be a very personal gesture.

5 POSSIBILITIES

"All art begins as a struggle against chaos." So André Malraux announced in *The Creative Act,* one of the volumes in the expansive study of art in many times and places that he published in the years after World War II. I admire the stentorian tones of Malraux's writings about art, with his discussion of the museum without walls and his vision of art as humankind's effort to "arraign the universe" and "triumph over destiny." Whether he was thinking about the Gandharan sculptors of third- or fourth-century India, or the anonymous Egyptians who painted portraits in the Roman period, or Titian or Beethoven, you can feel in his writ-

ing the impassioned voice of a man who believed that artists have a unique and essential place in the world. He was consumed by the authority of forms and the artist's power to reshape and reinvent those forms. But like many of the most compelling writers about the artist's "struggle against chaos," Malraux pitched that struggle in Olympian terms. He loved phrases like "the greatest painters' supreme vision is that of the latest Renoirs, the last Titians, Hals' last works." I love that hyperbolic rhetoric, too. The danger is that we end up seeing the dynamic engagement between authority and freedom as a privilege of the titans rather than as a struggle that's shared by all creative spirits, the very greatest and the merely good or fine.

The romantic view of the creative act—and Malraux was nothing if not a romantic—makes everything a matter of exceptionalism. That was certainly part of its appeal for Malraux, who by the 1940s had rejected the Marxist view of artists as locked in a symbiotic relationship with social, economic, and political affairs. But however much we may dote on the idea of the hero in history—and even people who recoil from the idea in principle are often fascinated by such

cases in practice—the place of the arts in civilization, as much if not more than it depends on the actions of uniquely inspired individuals, also depends on the engagement of an enormous number of practitioners; that is what interested Ruskin, Morris, and Schapiro about the Middle Ages.

All sorts of novelists, composers, choreographers, poets, and painters find themselves engaged in the challenges of authority and freedom that are the lifeblood of the arts. Art is a way of life—and not only or even essentially for geniuses. An artistic community—to whatever degree it may be joined by social, economic, or other concerns—is fundamentally united by the imperatives of a vocation as they are shaped in a particular time. Genius doesn't emerge ex nihilo. And it doesn't have a unique relationship with authority and freedom. Whatever truth there is to Walter Benjamin's comment, apropos of Proust's novel, that certain masterpieces begin or end a genre, it's equally true that every masterpiece reaffirms the fundamental character of a form. For every epochal achievement that we may see as an assertion of unexpected degrees of freedom (Beethoven's final quartets or Shakespeare's last plays), there are others that reaffirm the pressure of tradition

(an example is Raphael's neoclassical designs for tapestries representing scenes from the lives of Saint Peter and Saint Paul). For every creative spirit, the great as well as the merely good, there is a sense in which the wager is the same.

The authority of a tradition can add weight and impact to an achievement that is by no stretch of the imagination epochal, and that might even feel lightweight if it weren't for the individual voice being reformulated within the form. An example of this—there are certainly a large number—is the poetry of Edwin Denby, the New Yorker perhaps best known for his work as a dance critic in the mid-twentieth century and for his great admiration for Balanchine's ballets. Most of Denby's poems are sonnets. The pressure of the form gives a tough, impacted structure to the meandering impressions of the poet as he walks the streets of his beloved Manhattan or visits European cities. His tone can be brusque, muffled, cryptic, sometimes calculatedly crude. In his first collection, *In Public, In Private,* there's a poem, "Summer," about Denby's impressions as he walks around the Upper East Side and takes note of the men who might or might not be sexual partners. This is what he sees in Central Park:

> In the grass sleepers sprawl without attraction:
> Some large men who turned sideways, old ones on
> papers,
> A soldier, face handkerchiefed, an erection
> In his pants—only men, the women don't nap here.

The rhyme scheme gives the blunt, erotic observations a kind of elegance.

In another collection, *Mediterranean Cities*, the sonnet form provides ways of ordering the disorderly impressions of the bohemian traveler, whose experiences in Europe mingle reflections on the great monuments of classical civilization and casual encounters on the street and visits with friends. This is Denby in Athens:

> The traveling salesman helps me on the subway
> To a Ritz in Union Square; up Levantine streets
> I recognize afar the actual display
> Of the Parthenon, a brown toy in morning light.

Denby walks around the Acropolis:

> The keen Propylea spread like a male hand
> Grey rock glints as with violets, on the height glows
> Heavy-foreshortened like a body's grandeur
> Womanly, the Parthenon, yellow as a rose.

Back in New York, he recalls an encounter on a street while visiting Thebes:

> Wild-eyed, ragged in the crowding dusk a boy
> Holds out silently for sale a toy acrobat
> Daubed paper; I peer, take it with sudden joy;
> On the Hudson in a room that branches brush
> It lies on a table, hears the crunch of anguish.

Denby's restless eye and mind are given point and purpose by the sonnet form and its rhymes, which he uses or doesn't use, it all depends. He refuses to approach the form with the swagger of a modern titan, as you might say Robert Lowell does. Lowell runs roughshod over the form. Even as he embraces it he seems to be telling us that he's too big for it. If Lowell's sonnets succeed, it's because the assertion of freedom is so insistent, so overpowering. Denby is a man slipping into the form. He fits his bid for artistic freedom—which is also the liberty of the traveler, the erotic observer—into the timeless shape.

Art isn't evolutionary. Freedom doesn't continually chip away at authority. Freedom can as easily signify a

strengthening of authority, a reaffirmation of authority. Many scholars of the avant-garde have seen the twentieth century as a time when artists made an unprecedented commitment to new forms of freedom. Students of the visual arts frequently cite comments about the destructive element in the arts that Miró, Picasso, and Mondrian made at various points in their careers. But an argument can also be made that what characterized the arts of the twentieth century was a search for new forms of authority or new sources of authority. Twelve-tone music; the synthesis of world languages that Joyce developed in *Finnegans Wake;* Mondrian's ideas about what he called "pure plastic art": these were new forms of authority that the artist originated and then embraced. In the writings of Kandinsky, Klee, Malevich, Mondrian, and Schoenberg these new systems generate new freedoms.

In the 1920s, Mondrian developed a way of painting that he believed could say anything that painting had ever said, but with a greatly simplified and purified grammar and vocabulary. From then on, he limited his paintings to right angles, black lines, and rectangles of white, red, yellow, and blue. In "Plastic Art and Pure

Plastic Art," an essay he published in 1937, he argued that "art is fundamentally everywhere and always the same." Painting always involves "the *direct creation of universal beauty*" and "the *aesthetic expression of oneself.*" (The italics are Mondrian's.) He believed that with his verticals and horizontals and primary colors he could achieve an emotional and expressive range as great as the Old Masters, who worked with figures and narratives and variegated, sometimes unexpected forms and colors. The artist's goal, so Mondrian argued, was always "to achieve a balance between the subjective and the objective." The subjective elements in the work of the Old Masters were the figures and narratives, which became objective as they were arranged in a composition with an overarching logic. "The work of art must be 'produced,' 'constructed,'" Mondrian wrote. "One must create as objective as possible a representation of forms and relations. Such work can never be empty because the opposition of its constructive elements and its execution arouse emotion."

In his paintings of the second half of the 1920s and the early 1930s, Mondrian celebrated this demanding dialogue in works of voluptuous austerity. He pared

down his resources until it was possible to imagine a painting with only two black lines, one vertical and one horizontal, and one or two rectangles of color. But as the years passed, without ever abandoning these pure plastic relations, he began to assert new forms of freedom within the authority that he had almost single-handedly established. He found himself rethinking the possibilities. Authority turned out to be fluid. Mondrian multiplied the elements, doubling and tripling his black lines, crowding more and more rectangles of color within those lines, and adding colored lines. In his last years in New York, where he died in 1944, he set colored rectangles inside other colored rectangles. He preserved the strict rectilinearity of his elements and the implicit diagonal movement between forms, but with his last two paintings, *Broadway Boogie-Woogie* and the unfinished *Victory Boogie-Woogie,* the rows of small colored rectangles began to register as streams or waves of color.

Although it was only two years before his death that he had his first one-man show, at the Valentine Gallery in New York in 1942, Mondrian had been a figure much admired in international avant-garde circles since the

1920s. In the United States the new language that he created was embraced by a number of younger artists who were able to discover fresh possibilities within his pure plastic relations. Burgoyne Diller took the dance-like rhythms of Mondrian's later paintings and, while preserving the master's faith in the primary colors, forged his own choreographies, which ranged from the slowest adagios to the wildest rondos. Ilya Bolotowsky, while totally embracing Mondrian's strict verticals and horizontals, gave pure plastic painting a fresh hedonistic charge by creating lush orchestrations of a range of different reds, blues, or yellows within a single painting, something Mondrian hadn't done. In excavating and distilling the elements that he believed made art in all times and places fundamentally the same, Mondrian provided, at least for some, a guide to the future.

Probably the most famous of all twentieth-century statements about the importance of authority in the arts is T. S. Eliot's essay "Tradition and the Individual Talent," first published in 1919. "No poet, no artist of any art," Eliot asserted, "has his complete meaning

alone. His significance, his appreciation is the appreciation of his relation to the dead poets and artists. You cannot value him alone; you must set him, for contrast and comparison, among the dead"—against, in other words, the authority of tradition. That authority, much like the authority that Hannah Arendt spoke about, doesn't inhere in a particular person or thing. "What happens when a new work of art is created is something that happens simultaneously to all the works of art which preceded it," Eliot wrote. "The existing monuments form an ideal order among themselves, which is modified by the introduction of the new (the really new) work of art among them. The existing order is complete before the new work arrives; for order to persist after the supervention of novelty, the *whole* existing order must be, if ever so slightly, altered; and so the relations, proportions, values of each work of art toward the whole are readjusted; and this is conformity between the old and the new." So far as Eliot was concerned, the poet's emotions aren't heartfelt in any usual sense of that word, but are "an expression of *significant* emotion, emotion which has its life in the poem and not in the history of the poet. The emotion of art is impersonal."

For all that's persuasive in Eliot's essay, I think he pushed authority too much in the direction of something singular and unified; there's a whiff of authoritarianism in his view of authority. That's where I believe he lost his way. I'm not sure he recognized how idiosyncratic and variegated the exercise of creative freedom can be. The debate between authority and freedom doesn't achieve a smooth resolution every time. Michelangelo's architecture left authority—and the "authorities"—reeling. The artist can approach authority in different moods, from grave, reverent, and saturnine to skeptical or even satirical. The revival of interest in classical stories, images, and structures that swept through the arts in Europe in the years around World War I (Eliot was part of it) generated many views of authority and many forms of freedom. You see this new classicism in works as varied as Joyce's use of the narrative of Homer's *Odyssey* in *Ulysses;* the reimagining of Apollo, Orpheus, and Greek athletics in the trilogy of ballets on which Stravinsky and Balanchine collaborated; Satie's Platonic chamber opera, *Socrate;* and Picasso's immersion in aspects of Mediterranean culture ranging from the legend of the Minotaur to the austerely erotic figures engraved on Etruscan mir-

rors. De Chirico's disquieting vistas, with their classical statuary and colonnades, fueled the altogether anti-classical visions of the Surrealists.

An artist's engagement with authority and freedom can take many different forms. Sometimes the playful and melancholic elements come together and the artist's engagement with authority suggests a saturnine comedy. You find that equivocal atmosphere in many works by Balthus, the brilliantly independent painter who was friends with André Derain and Alberto Giacometti and died in 2001 at the age of ninety-two. Balthus's paintings can be simultaneously stormy and serene. His attitude toward the past is mystical—a reverent but radical reimagining of the past that recalls the observation of the scholar Gershom Scholem, in the opening pages of his book *On the Kabbalah and Its Symbolism,* that in the hands of the mystic personality "the sacred text is smelted down and a new dimension is discovered in it. In other words: the sacred text loses its shape and takes on a new one for the mystic." Another kind of mystical transformation—a sort of sinister game—often animates the fiction of Jorge Luis Borges. "Pierre Menard, Author of the *Quixote*,"

Borges's famous story about a man who replicates *Don Quixote* word for word and produces something better than the original, offers a perverse allegorical twist on the perpetual struggle between authority and freedom. Authority can be a house of mirrors. A great artist turns round and round in that house of mirrors and somehow feels free. In the final scene of Balanchine's *Vienna Waltzes,* the ballerina Suzanne Farrell, for whom the role was first conceived, dances before a bank of mirrors to an arrangement of waltzes from Richard Strauss's *Der Rosenkavalier.* She's simultaneously acknowledging the weight of history—the long history of the waltz as it unfolds in the four earlier sections of the ballet— and asserting her own freedom as a dancer. The past becomes a mask that reveals the truth.

The challenges and even the comic challenges involved in the artist's struggle with authority were recurrent themes in the correspondence between two writers who did much to promote European modernism in mid-twentieth-century America, Guy Davenport and Hugh Kenner. Davenport and Kenner were initially brought together by their mutual admiration for the poetry of Ezra Pound; Kenner was in the early

stages of research for what would be his finest book, *The Pound Era*. In the years when the letters were flying back and forth between the various places where they were teaching, Davenport, who had been trained as a classicist and had a PhD in English, was turning more and more to writing poetry and fiction. For Kenner and Davenport, tradition was packed with ambiguities and paradoxes. Authority was both an imperative and a conundrum. Kenner was trying to understand how the poetry of Sappho and other Greek writers, often known only in fragmentary forms, shaped some of Pound's art. Davenport observed early on in their correspondence that "the Fragment seems a model for the Pound lyric." Some might regard that as a strange way to describe the authority of tradition, considering that it's a tradition that arrives in a broken, fractured form. For Davenport, authority was unstable, the possibilities to be gleaned and then grasped, one by one, through an act of the imagination. Later, reflecting on Pound, he wrote, "I think Pound came by his love of sharp clarity from things mediaeval: Latin verse, Romanesque stone-carving, book illumination. He immediately perceived that exact lines always go with light and that there is

a sharp intelligence and moral firmness somewhere nearby. And so on. Coals to Newcastle."

Both Davenport and Kenner were fascinated by the idea of counterfeits. They recognized that all traditionalists are in some sense counterfeiters; they wondered if counterfeiting sometimes turned out to be an assertion of freedom. Kenner was writing a book called *The Counterfeiters.* He worried "whether the visual arts do not play a dangerous game with counterfeiting, right at their hearts?" To which Davenport responded, "Naw. The connoisseur (a counterfeit word, by the way; it doesn't exist in French, like 'double entendre') finds a cool pleasure in the limitless possibilities of perception and the artist couldn't care less." He reminded Kenner that the fascination with the sculpture of Praxiteles that artists had shared for centuries wasn't based on any actual known work by the artist; they are all lost. Further, "Brahms' Variations on a Theme by Haydn is on a theme NOT by Haydn (engraver's error). Not a line of Da Vinci's survives of The Last Supper." Davenport celebrated "plagiarism, quotation, tag, echo, parody, forgery, counterfeit. Do you know your Thomas Mann? He packed his novels with a fascinated, wholly morbid,

study of the whole subject, especially *Doctor Faustus*." Kenner, who had just started reading Borges, recommended "Pierre Menard, Author of the *Quixote*." The authority of the past inspired a glorious treasure hunt in the hundreds and hundreds of letters that passed between the two men.

The artist's freedom is what keeps authority alive. Some of the greatest artists dig deep into aspects of authority that have been lost or forgotten or misunderstood. Anni Albers, who was born in 1899 and studied at the Bauhaus in the early 1920s, brought a fresh, modern attention to what had in earlier times all too often been dismissed as the crafts traditions. Her greatest achievements, which she referred to as "pictorial weavings," were mostly produced in the 1950s and early 1960s. These relatively small compositions, executed on a handloom using many different kinds of yarn, generate an astonishing range of emotions. In *Variations on a Theme*, tiny bundles of white and brown yarn create a delicate and surprisingly provocative visual music; the elements, arranged in rows as if hieroglyphics on an

ancient monument, form syncopated, enigmatic mes-
sages. *Pasture,* as its title suggests, is an abstract para-
dise, with a plangent gathering of greens complicated
by abstract floral arabesques in red, white, and blue.
Albers's pictorial weavings are full of hints, suggestions,
half-buried allusions, all of them drawn together and
sharpened by the steadying order of the textile's warp
and woof—by, in other words, the authority imposed
by the art of weaving.

Albers dedicated *On Weaving,* the book she pub-
lished in 1965, to "my great teachers, the weavers of
ancient Peru." In the weavings of pre-Columbian
Peru, of which Albers herself was able to collect minor
examples, she found a source of inspiration that sus-
tained her own abstract inventions. *On Weaving* was
very much a treatise; it included discussions of looms
and diagrams of the various weaves. Over and over
again, Albers argued that only a close study of the fun-
damentals of the weaver's art could release the artist's
imagination. Of one method of construction she wrote,
"It is interesting to note that this most practical of
all thread constructions is at the same time also the
one most conducive to aesthetic elaborations." Some-

times it's the simplest forms of authority that provoke the greatest outpourings of freedom. "For those of us concerned in our work with the adventure of search," Albers observed, "going back to beginnings is seeing ourselves mirrored in others' work, not in the result but in the process. Therefore, I find it intriguing to look at early attempts in history, not for the sake of historical interest, that is, of looking back, but for the sake of looking forward from a point way back in time in order to experience vicariously the exhilaration of accomplishment reached step by step." In ancient Peruvian textiles, Albers found her way forward. She prized "the highly intelligent and often intricate inventions of lines or interlocking forms. Their personages, animals, plants, step-forms, zigzags, whatever it is they show, are all conceived within the weaver's idiom." She praised the "infinite phantasy within the world of threads, conveying strength or playfulness, mystery or the reality of their surroundings, endlessly varied in presentation and construction, even though bound to a code of basic concepts, these textiles set a standard of achievement that is unsurpassed."

From her study of Peruvian textiles Albers learned

"that playful invention can be coupled with the inherent discipline of a craft. Our playfulness today often loses its sense of direction and becomes no more than a bid for attention, rather than a convincing innovation. Limitlessness leads to nothing but formlessness, a melting into nowhere. But it is form—whatever form it may be—that is, I feel, our salvation." Albers refused to believe that "a limitation must mean frustration. Rather, to my mind, limitations may act as directives and may be as suggestive as were both the material itself and anticipated performance. Great freedom can be a hindrance because of the bewildering choices it leaves to us, while limitations, when approached open-mindedly, can spur the imagination to make the best use of them and possibly even to overcome them." There may be no clearer description of the dynamic between authority and freedom than these words by the most important weaver of the twentieth century.

⑥ A PLACE APART

Nearly all of the artists, writers, and musicians I've written about in these pages are people whose work I've admired for years. But only in the past decade have I considered writing about them as I have here, as part of an exploration of the nature of the arts. For a long time I had no interest in even considering a question as basic as why the arts matter. The answer seemed self-evident. The arts mattered because they held me and moved me. Explanations were a trap— a game for pedants. Why belabor the obvious? I knew that the arts had always, at least to some degree, been at the mercy of forces beyond the artist's control. Who

could doubt that church and state, captains of industry, changing fashions, and rivalries with other artists had shaped what artists did and didn't do? Of course I was interested in all of that. But I believed that what ultimately mattered was how I felt when I saw the painting or heard the sonata or read the poem. Looking back, I would say that there was something almost utopian about my untroubled attitude toward the arts. In college I heard a disk jockey on one of the radio stations say that the Beatles had "reached the lonely plateau of the art form." I thought that was a hilariously snotty thing to say about the Beatles. I was so amused that I inscribed that crazy line on the inside of the door of the closet in my bedroom. But of course I did believe in the lonely plateau of the art form, although I was inclined to look for it in Matisse or Proust rather than the Beatles. I don't mean to say that I didn't like the Beatles. I did. In high school I bought their album *Revolver* the day it came out.

As a teenager, I certainly didn't need anybody to tell me why Jane Austen, Vivaldi, or Picasso—or, for that matter, Bob Dylan or Aretha Franklin—held my attention. I couldn't remember a time when that kind

of artistic variety hadn't been a part of my family's life—an important part of our life. I had a very lucky upbringing. I was taken to museums when I was still a little boy. My mother, juggling four young children, found her refuge at the piano, practicing the classical trios and quartets that she played with her friends on evenings when we siblings had to tiptoe around the house. My father, a scientist, had dabbled in sculpture before he received his PhD; a blocky plaster figure that he'd done before I was born was always on display somewhere in the living room. The bookshelves in our house were full of novels, poetry, philosophy, and commentary on all of the above. There were reproductions of Vermeers and Picassos on the walls. My parents were always discussing the new books, movies, and plays that were reviewed in the magazines that poured into the house. And in our liberal household nobody doubted that art and politics and high art and popular art could live happily together. Nobody would have been surprised if you'd put a copy of Joyce's *Dubliners* in your back pocket when you went on one of the marches protesting US involvement in the war in Vietnam that my family attended together. And nobody raised an eye-

brow when a friend of my parents commented—this must have been the mid-1960s—that he now looked to the Beatles for the kinds of pleasures he used to find in Mozart.

By the time I was in college—I was a freshman at Columbia in the fall of 1968—I was aware that people had been arguing about the meaning and value of art practically forever. But the arguments, however interesting, felt remote. I knew that some of the great modernists—T. S. Eliot and Ezra Pound come immediately to mind—had been reactionaries; they believed that democratic societies were often the enemy of the arts. That ought to have offended my liberal sensibilities. But I didn't feel perturbed, because I felt that the question was fixed in amber—an artifact of an earlier, darker time, and therefore irrelevant to me. In freshman year we read Plato's *Republic* and discussed his worries about the anarchic power of music. I loved Tolstoy and enjoyed the high dudgeon of *What Is Art?*, that furious tract against the decadence of art. *What Is Art?* struck me as a magnificent curiosity, nothing more. I remembered my father bringing back from Europe copies of the Henry Miller novels that were

still banned in the United States, but that bit of lawlessness was just an amusing and harmless escapade. The arts in all their variety were all around us, so any discussion about their purpose or place in society seemed, frankly, a bit academic. Even book burnings felt beside the point, which was maybe a little surprising in a Jewish family with relatives who a generation earlier had barely survived the Holocaust. Book burnings were something seen in old newsreel footage as part of the features about World War II that my father liked to follow on TV. When Truffaut's movie *Fahrenheit 451* came out in 1966—it was, admittedly, a chilly rendering of a hot topic—the idea that books might be endangered struck me as a little silly.

If now, more than a generation later, I find myself called upon to try to explain why the arts matter, it certainly isn't because I'm living in a country where there is a threat of anything resembling the Nazi book burnings, Stalinist gulags, or mass murders and reeducation programs that the Maoists encouraged in the name of the Cultural Revolution. People in many parts of the world still risk their lives and their freedom when they embrace certain ideas about the value of art, but such

dangers do not exist in the United States, where I live, or in most of Western Europe, or in some other parts of the world. Nevertheless, there is reason for concern, even in the United States.

It now seems to me that the attitude toward the arts that I took for granted when I was growing up— the belief that the arts have their own, independent significance—has prevailed during only a couple of periods in the United States and Western Europe in the past 150 years. Attitudes toward the arts have been subject to what may be a cyclical process, with periods when they have been prized for their freestanding value alternating with periods when many thoughtful people have insisted on interrogating their social or political significance—and judging them on that basis. The first quarter of the twentieth century was a halcyon period for the independence of the arts. One has only to think of the explosive excitement around Sergei Diaghilev's Ballets Russes, with its revitalized vision of theatrical dancing and theater more generally, or the fertility of the new poetry, including works by T. S. Eliot,

Marianne Moore, Wallace Stevens, William Carlos Williams, and so many others. Although new work often met with violent detractors—the response to the Armory Show in New York in 1913, which introduced many Americans to the work of Matisse, Picasso, and Duchamp, is a famous example—the critique of the arts wasn't by and large addressed to the work's political or social significance or lack thereof; the new painting and sculpture were criticized on artistic grounds, although admittedly often rather crudely. In his *Autobiographical Novel*, the poet Kenneth Rexroth observed of life in Greenwich Village in the 1920s that he and his friends believed there was no simple political test that could be applied to works of art. "Kandinsky was a revolutionary painter; Upton Sinclair was a reactionary novelist, however they marked their ballots."

It was in the 1930s, amid the catastrophic economic, social, and political upheavals of the Depression and the rise of authoritarian regimes on the Right and the Left, that more and more people, including many artists, writers, and musicians, began to insist that their work be viewed and evaluated through a social or political lens. It wasn't only Hitler and Stalin and the

men in their inner circles who believed that any artistic style amounted to a political and social statement. As we have seen, Picasso's *Guernica* was subjected to those sorts of tests by Western intellectuals of some distinction. The French Communist poet Louis Aragon was involved in a heated argument with the painter Fernand Léger, with Aragon insisting that representational art was the only art that could serve the needs of the common man and therefore the only art that anybody should be making. At the American Artists' Congress in 1936, the painter Peter Blume, himself by many measures a modernist, declared that modernism reflected the values of a now defunct "leisure-class culture" and that "this typically Fascist idea of a large subject class dominated by a highly civilized minority was enormously popular with the esthetes of the late 'Twenties." Similar arguments and debates rocked the literary and musical worlds. Abstract art, atonal music, and literary experimentation, although they were by no means entirely eclipsed in the 1930s, were received with increasing skepticism by the educated public; they tended to take a backseat to what were seen as more socially significant forms of expression.

As the 1930s faded into the 1940s this passionate desire to align social and political justice with certain pictorial, musical, or literary styles was on the wane. Even many artists and intellectuals who had felt comfortable with some of Stalin's dictates as to what sort of art should and shouldn't be made were horrified by the annihilation by Stalin and his henchmen of just about anybody in the Soviet Union who had diverged even the least bit from the official line. Considering the role that the United States and Great Britain had played in the defeat of fascism, more and more artists, writers, and musicians found themselves thinking that the Western democracies, whatever their failures when it came to matters of social and economic justice, were the only places left where one might pursue a life in the arts with some measure of independence. In the 1940s and 1950s, the American magazine *Partisan Review,* led by writers who had been Marxists and Trotskyites in their younger days, embraced socialism in the political and economic realms while celebrating the arts for their freedom from all political, social, and economic imperatives. By the later 1950s even in Europe, where Soviet sympathies remained very much alive, a new

generation of decidedly apolitical writers and artists, among them Samuel Beckett and Alberto Giacometti, reaffirmed the old idea that creative thinking was independent—maybe even apolitical—thinking.

What seems inarguable to me, looking at cultural attitudes and institutions during the past decade and more, is that we are once again in the midst of a dramatic change. The profound political, social, economic, and environmental challenges that we face—challenges as grave if not graver than those of the 1930s—have pushed people to ask what the arts can do to help. Everywhere we look, there is a renewed focus on the relevance of the arts. Much of the discussion that we're hearing echoes ideas presented by Leon Trotsky nearly a century ago. "The effort to set art free from life, to declare it a craft self-sufficient to itself, devitalizes and kills art." Trotsky wrote this in 1924 in his book *Literature and Revolution.* "The very need of such an operation," he pursued, "is an unmistakable symptom of intellectual decline." He saw the "megalomania of aesthetics [as] turning our hard reality on its head." The effort

to separate artistic life or experience from social or economic experience was, so Trotsky argued, bound to fail. He went on to write about the great Cologne Cathedral, and how "without knowing what a medieval city was like, what a guild was, or what was the Catholic Church of the Middle Ages, the Cologne cathedral will never be understood." There's no question that our experience of a medieval cathedral will be enriched by whatever we know about the people who made it and the ideas that they embraced and the world in which they lived. I would also insist that the grandeur of the cathedral—the impact that it had on the men and women of the Middle Ages and the impact that it has on us today—was shaped by the evolving language of architecture and how particular builders, stonemasons, and sculptors engaged with that language.

Among the artists whom Trotsky singled out for criticism in *Literature and Revolution* was Andrey Bely, the novelist, poet, and theorist of literature who died in Moscow in 1934. In 1909, Bely published an essay entitled "The Magic of Words," in which he described the most fundamental and elemental aspects of the act of literary creation, which he saw as involving the assembly of individual words into striking arrange-

ments of sound and sense. "If words did not exist," he wrote, "then neither would the world itself." He said that when he named an object, "I thereby assert its existence." Marshaling these words, he felt himself "to be the creator of reality." All of this, not surprisingly, infuriated Trotsky, who complained that Bely found himself "in a blind alley of words." "Bely," Trotsky wrote, "declares that 'the foundations of everyday life for me are stupidities.' And this is in the face of a nation which is bleeding to change the foundations of everyday life." So far as Trotsky was concerned, the artist really had no choice. "Torn from the pivot of custom and individualism," he wrote, "Bely wishes to replace the whole world with himself, to build everything from himself and through himself, to discover everything anew in himself—but his works, with all their different artistic values, represent a poetic or spiritualist sublimation of the old customs." What for Bely was the independence of art was for Trotsky the artist's narcissism. At the core of Trotsky's critique there was a belief that anybody who saw the act of creation as beginning with the artist and the tools of the artist's trade was guilty of some sort of sublimation or denial. I find this unacceptable.

Trotsky's investigation of formalism wasn't an attack

on art in general. It wasn't even exactly an attack on formalism, of which he wrote in *Art and Revolution* that "the methods of formal analysis are necessary, but insufficient." Trotsky had an exalted view of art, which he believed revealed aspects of human experience that would otherwise remain hidden. "How can we transform ourselves and our lives without looking into the 'mirror' of literature?" he asked. He argued that artists should be left free to experience the world in their own way. This was a highly controversial position in Soviet Russia in the 1920s. Trotsky's ideas about art, according to his biographer Isaac Deutscher, "outraged the bureaucrat to whom it denied the right to control and regiment intellectual life." In his last years in exile Trotsky argued, in a statement written in collaboration with the Surrealist poet André Breton, for "complete freedom for art." But for Trotsky there was always an ulterior motive, because the artist could not "serve the struggle for freedom"—the revolutionary struggle— "unless he subjectively assimilates its social content." Artistic freedom was justified by the artist's unique ability to illuminate the social or economic or political situation. To this day this idea—which I believe

endangers art's freestanding value and significance—is echoed in the thinking of many people who have rejected Trotsky's revolutionary aspirations.

Of course there have been many times in the past hundred years when it has seemed impossible to disentangle the arts from the onslaught of current events. In the 1930s the arts were hard-pressed in Russia and Germany and eventually the rest of Western Europe, as creative spirits found themselves censored, silenced, and in many instances annihilated by political and social forces to the Left and the Right. The closing of the Bauhaus; the banning of the avant-garde in Russia; the "Degenerate Art" exhibition mounted by the Nazis; the deaths of so many creative figures in the gulags; the many artists, writers, and musicians forced during World War II to seek safe haven in Great Britain, the United States, or South America: surely these horrific and tragic events have some lesson to teach us. What's less sure, so far as I'm concerned, is what that lesson might be, beyond the obvious one, namely that authoritarianism has been anathema to the arts, as to

so many other things. That ideological forces have put art and artists in the crosshairs—and annihilated whole creative communities and movements—is a human tragedy of epic proportions. That leaves unanswered the question of what these authoritarian assaults on the arts actually tell us about the work under attack. I doubt many people would come right out and say that a particular work of art is good simply because Hitler or Stalin thought it wasn't. But for many educated people there is some feeling, although not always fully articulated, that a work of art that Hitler or Stalin regarded as a threat has received a kind of perverse—upside-down—imprimatur. This argument won't take you very far.

We are fascinated by confrontations between artists and power brokers of all kinds. We see or at least believe that we're seeing in these sometimes charged encounters the creative imagination facing up to life's exigencies. There's nothing surprising about this. Here two kinds of power come into contact and maybe even face off—artistic power and temporal power—whether the dramatis personae are Michelangelo and Pope Julius II in the sixteenth century or Boris Pasternak

and Joseph Stalin in the 1930s. Some observers hope that the study of a creative person's worldly travails and triumphs will reveal something about how raw materials and experiences are transformed into paintings, sculptures, novels, poems, dances, sonatas, and symphonies. But however stirring these encounters may be from a biographical standpoint, I'm not sure how much they tell us about the character and quality of the art in question. Marxists and non-Marxists alike often fall for a simplistic vision of the artist as shaped, whether as victim or victor, by the appetites and dictates of the patron and, in more recent times, the public. Contemporary audiences have a soft spot for avant-garde attitudes—which they associate, not always accurately, with anti-establishment attitudes—and are generally more willing to endorse artists who inspire controversy than artists who have a relatively comfortable (or entirely comfortable) relationship with the people who hold the reins of power. But great artists are not necessarily contrarians. I would certainly not want to dismiss the achievement of Peter Paul Rubens. He was employed by the men and women who held the fate of seventeenth-century Europe in

their hands. All the while he was exercising, in response to commissions from those people, an extraordinary imaginative freedom.

For every masterwork that has put an artist in the crosshairs of some political or religious authority there is another masterwork that has been embraced by whoever the powers of the time happened to be. Great, good, and mediocre artists have found themselves in trouble with some authority, sometimes with tragic consequences. And great, good, and mediocre artists have had an untroubled relationship with whatever the powers of the time. Anna Akhmatova's long poem "Requiem," the wrenching commemoration of the victims of Stalin's reign of terror as a modern secular Passion, although begun in the 1930s, did not see the light of day in the Soviet Union until after Stalin's death in 1953. T. S. Eliot's "The Waste Land," in its own way a scathing attack on the nature of modern society and modern experience, never so far as I know ran into trouble with the censors, at least in Great Britain, where he lived, or the United States, where he was born. Akhmatova's freedom of speech was denied. Eliot's wasn't. But I doubt that anybody would argue that their treatment

at the hands of democratic and authoritarian govern-
ments ought to affect our judgment of the quality of
their work. At least I hope it wouldn't.

Even if we acknowledge that the political opposition
that some artists face doesn't tell us anything much
about the character or quality of their work, we are
left with the question of what we're to make of the
work of an artist whose politics troubles us deeply.
The case of William Butler Yeats, who was born in
1865, is especially germane to any exploration of the
relationship between art and society. Yeats grew up in
an artistic Irish Protestant family; both his father and
his brother were painters. For a time he was a socialist
and for a time he was a member of the Irish Senate. In
his early years he embraced the fin de siècle's religion
of art-for-art's-sake and the ivory tower. His interests
in mythology, esotericism, and theatrical experimenta-
tion suggested an Irish version of tastes and interests
that had shaped the avant-garde in France and beyond.
But in the years leading up to his death in 1939, Yeats
became a supporter of Mussolini and the group known

as the Blue Shirts, a fascist paramilitary organization that had an impact on Irish political life. It comes as no surprise that many of the poet's English admirers were troubled by his unabashedly anti-democratic affiliations.

Almost immediately after Yeats died, W. H. Auden chose to confront this difficult situation. He produced not only one of his most famous poems, "In Memory of W. B. Yeats," but also two essays about Yeats. It was a time of dramatic change in Auden's own life. He had just moved from Great Britain to the United States, which left him open to the accusation that he was abandoning his homeland in the time of its greatest peril. He was also turning away from the Marxist ideas that had absorbed him, along with so many others, in the 1930s. His critics feared that he was in retreat—yearning for the ivory tower. He might not have disagreed. In a manuscript written but not published at the time, "The Prolific and the Devourer," he observed that "if one reviews the political activity of the world's intellectuals during the past eight years . . . one is compelled to admit that their combined effect, apart from the money they have helped to raise for humanitarian purposes (and one must not belittle the value of that) has been

nil." He insisted that the artist—at least the artist he now hoped to be—"is not pretending to give an answer to anything." And he offered an ironic riposte to artists who imagined that they had some political clout. "If the criterion of art were its power to incite to action," he wrote, "Goebbels would be one of the greatest artists of all time." Art, Auden was arguing, had an authority of its own. Yeats, both the man and his work, provided the opportunity to answer some essential questions about the artist's place in the world.

"In Memory of W. B. Yeats" contains four of the most famous words Auden ever wrote: "poetry makes nothing happen." This vision of the autonomy of art needs no explanation beyond the words of the poem. But in the context of a longer discussion of the relationship between authority and freedom, it's worth considering Auden's evolving ideas about art and politics—and his view of the controversy about Yeats and his politics. In an article entitled "The Public v. the Late Mr. William Butler Yeats," published in *Partisan Review* in 1939, Auden framed the conflict as a trial, with presentations by "The Public Prosecutor" and "The Counsel for the Defense." To the prosecutor's accusation that a great

poet had to have "a profound understanding of the age in which he lives" and "a working knowledge of and sympathetic attitude towards the most progressive thought of his time," Auden responded that this sounded like little more than "the filling up of a social quiz." He believed "the poet is a man of action," but that his action took place in "the field of language." There was a virtuous lucidity about Yeats's use of language. "However false or undemocratic his ideas," Auden wrote, "his diction shows a continuous evolution toward what one might call the true democratic style. The social virtues of a real democracy are brotherhood and intelligence, and the parallel linguistic virtues are strength and clarity, virtues which appear ever more clearly through successive volumes by the deceased." In the second essay, "Yeats: Master of Diction," which appeared something like a year later in *The Saturday Review,* Auden said that he was encouraged to find that although Yeats showed "scant sympathy with the Social Consciousness of the Thirties," he was still regarded as a great poet. That this writer who had felt the pull of fascism continued to be popular, even in the fraught political atmosphere of the late 1930s and the begin-

nings of the war against fascism, suggested to Auden that a beautifully wrought poem might still exert an independent power.

When first published in *The New Republic* on March 8, 1939, "In Memory of W. B. Yeats" contained only two of the three sections we now know, the first and the last. The juxtaposition of these and the central section, which appeared when the poem was republished in *The London Mercury* a month later, dramatizes the tension between the public and the private artist, the artist acclaimed in the world and the artist who, whatever his failings, remains true to his vocation. The opening and closing sections feel ceremonial; the poet's voice is formal. Edward Mendelson, in his biography of Auden, wrote that "the opening section transforms traditional elegy into a bleak new mode." Auden paints a picture of a bone-chilling season, the time of the poet's death. It was "the dead of winter" and "the brooks were frozen, the airports almost deserted." Auden sets the stage— "The day of his death was a dark cold day"—for what amounts to the great funeral oration that he offers in the final part of the poem. Mendelson described that closing section as "ritual and allegory." It's resplen-

dent, something that might be intoned in Westminster Abbey:

> Earth, receive an honoured guest:
> William Yeats is laid to rest.

But juxtaposed with these two sections is something entirely different. The central ten lines are conversational, casual. It's as if somebody is speaking to Yeats sotto voce—about his pitfalls, his follies, and his resilience.

> You were silly like us; your gift survived it all:
> The parish of rich women, physical decay,
> Yourself.

Scholars and critics who've examined Yeats's fascist sympathies in the 1930s have argued that they were fueled not by firm ideological principles but by a sentimental fascination with the aristocracy and their manners and stately homes. Auden concurred: this is Yeats's silliness. But that can't diminish the poet's sense of vocation—his carefully nurtured "gift." Whatever Yeats believed ought to happen in the world—and that

included political developments that clearly horrified Auden—he remained engaged first and last with what was happening in his poetry. It is here in the poem, in the midst of the gossip about the "parish of rich women" and the poet's "physical decay" that Auden makes his great declaration—or could it more properly be characterized as a confession?

> Now Ireland has her madness and her weather still,
> For poetry makes nothing happen: it survives
> In the valley of its making where executives
> Would never want to tamper, flows on south
> From ranches of isolation and the busy griefs,
> Raw towns that we believe and die in; it survives,
> A way of happening, a mouth.

Here, between the elegy and ritual of the opening and closing verses, Auden comes to the fundamental distinction between *doing* and *making*. When Yeats threw his support to Mussolini and the Irish fascists he was doing something. But when he turned to his poetry, he was making something. Poetry is—so Auden explains—"a way of happening, a mouth." Art is a realm of its own—a realm that touches us and affects

us (our "ranches of isolation" and "raw towns that we believe and die in") but remains a world apart. It's not only a matter of words. The words are a way of living and knowing. And the words, if beautifully made, can survive even a person's follies.

Some years later, Auden returned to the theme in a much less well-known poem. "The Maker" isn't a work with anything like the grandeur or gravitas of the verses Auden dedicated to Yeats. The question of the relationship between making and doing is treated almost melodramatically, as if Auden were imagining a scene in an opera. But there's something bracing about the clarity with which he once again strikes his theme.

> Excluded by his cave
> From weather and events, [the maker] measures
> Days by the job done, and at night
> Dreams of the Perfect Object, war to him
> A scarcity of bronze, the fall of princes
> A change of customer.

Nothing matters to the artist—to the maker of the title of the poem—except the perfect object. And because

so many desire that object, it turns out it's the prince who depends on the artist, not the other way around. This perfect object, Auden observes near the end of the poem, although not necessarily immune from insult, "may avenge it."

Far from offering an escape from the world, the arts present one of the most difficult and hard-fought ways to enter into the life of our time or any other time. What the artist must first accept is the authority of an art form, the immersion in what others have done and achieved. Once the artist has begun to take all that in— it's a process that never really ends—there comes the even greater challenge of asserting one's freedom. It's the limits imposed by a vocation that make it possible to turn away from the pressures of the moment and think and feel freely—and, sometimes, give the most private emotions an extraordinary public hearing. If art is the ordering of disorderly experience, and I don't know how else to describe it, then the artist must be true both to the order and to the disorder. These are the trials of the artist and the artistic vocation. They

shape the experience of anybody who reads a novel or looks at a painting or listens to a piece of music.

Contemporary life promises unlimited options—and sometimes delivers them. If we're able to avail ourselves of a never-ending supply of digital information, we can connect with our family, friends, and colleagues, binge watch or listen to anything that strikes our fancy, and buy stuff so effortlessly that we're in danger of imagining there's no price attached. We can do so much with what seems like so little effort that doing itself becomes disembodied, wonderfully in some instances, bewilderingly or disturbingly in others. Some will say that the situation is new—of course, our lives in cyberspace are unprecedented—but the desire to inhabit a time and place outside of time and place isn't new at all. This is where the arts come in. They've always been a time out of time and a place out of place. But they're also right here, right now. They're both adamantine and ethereal, physical and metaphysical. This complexity is what thrills us in Virginia Woolf's *Mrs. Dalloway*, Michelangelo's Laurentian Library, Aretha Franklin's *Amazing Grace*, Mozart's Piano Concerto No. 27 in B-flat Major, Yeats's "Among

School Children," Mondrian's *Broadway Boogie-Woogie,* Shakespeare's *King Lear,* and Anni Albers's *Pastoral.* We thrill to patterns of authority and freedom—which are patterns of limitedness and limitlessness. We engage with these patterns through the ordering of words on a page, the sounds of instruments and voices in the air, and the shaping of stone, paint, or thread. Authority sometimes registers as palimpsests and pentimenti. Freedom sometimes registers as a break in the pattern that generates a new pattern. The patterns are fixed and fluid, peremptory and evolutionary.

Because the arts are the products of a process that stands apart from so much of our social, economic, and political life, they move us and excite us unlike anything else in our lives. When we rush to label them—as radical, conservative, liberal, gay, straight, feminist, Black, or white—we may describe a part of what they are, but we've failed to account for their freestanding value. And without that the arts are nothing. The artist in the act of creation—working through particular words, sounds, colors, shapes, and their infinite combinations—almost inevitably risks irrelevance. But the decision to reject doing in favor of making, which

some have described as a retreat into self-absorption and narcissism, is in fact an act of courage. Artists reenter the world by sending the work that they've made back into the world, where it lives on—independent, inviolable—in what Auden called "the valley of its making." That is a place apart—paradoxically, triumphantly apart.

ACKNOWLEDGMENTS

Dan Frank, editor and friend, embraced this book from the beginning, but to my great sorrow has not lived to see it published. He is much missed. My appreciation to the extraordinary team at Knopf: Ellen Feldman, John Gall, Deborah Garrison, Vanessa Haughton, Maggie Hinders, Kathy Hourigan, Andy Hughes, and Jess Purcell. This is the fifth book on which some of us have worked together.

The ideas expressed here have grown over many years and owe something to the friendship, conversation, and views of Leland Bell, Paul Berman, Arlene Croce, David Daniel, Gabriel Laderman, Deborah Rosenthal, and Leon Wieseltier.

I owe a debt of gratitude to Joshua Cohen, Mitchell Cohen, Douglas Crase, Michael Dellaira, Nick Lyons,

Nathan Perl-Rosenthal, Brenda Wineapple, and Eli Zaretsky for their criticisms of the manuscript.

A salute to Jennifer Lyons. Much love to Teri Perl, Jessica Marglin, Suzanne Perl-Marglin, and Emmanu-elle Marglin-Rosenthal. And remembering my friend Carol Brown Janeway—who brought me to Knopf in the first place and I'm pretty sure would have approved of this book.

NOTES

1 THE VALUE OF ART

4 "long quarrel between": From Apollinaire's "La Jolie rousse," in *Calligrammes: Poèmes de la paix et de la guerre (1913–1916)*. The French is "Je juge cette longue querelle de la tradition et de l'invention / De l'Ordre et de l'Aventure." Guillaume Apollinaire, *Oeuvres poétiques* (Paris: Libraire Gallimard, 1956), p. 313.

8 "Why aren't you doing something": Doris Lessing, *The Golden Notebook* (New York: Harper Perennial, 2008 [1st ed. 1962]), p. 609.

9 "brain-spun": Leo Tolstoy, *What Is Art?*, trans. Almyer Maude, intro. by Vincent Tomas (New York: Library of Liberal Arts, 1960 [1st ed. 1898]), p. 113.

9 "Art is a lie": From a statement Picasso gave to Marius de Zayas, translated by Zayas and published in *The Arts* in New York in May 1923. See Dore Ashton, ed., *Picasso on Art: A Selection of Views* (New York: Da Capo, 1988 [1st ed. 1972]), p. 3.

11 "though the manner of executing": John Ruskin, *The Stones of Venice: Volume the Second: The Sea-Stories* (Sunnyside, Orpington, Kent: George Allen, 1886), vol. 2, p. 172.

13 "I was flung spinning": Alfred Kazin, *A Walker in the City* (New York: Harcourt, 1979 [1st ed. 1951]), p. 95.

13 "the minds of the young": Ralph Ellison, *The Collected Essays*

of Ralph Ellison, ed. and intro. by John F. Callahan (New York: Modern Library, 2003 [*Shadow and Act* 1st ed. 1964]), p. 51.

13 "the southwestern jazz of the thirties": Ibid.

13 "busy creating out of tradition": Ibid.

2 PLANNING AND MAKING

22 The problem is that the act of creation: Mary McCarthy made this distinction between art and act with great wit and precision in her discussion of Harold Rosenberg's essay "The American Action Painters." "Once you hang an act on your living-room wall, a weird contradiction develops, which is inherent in the definition (or myth) of action painting itself; an 'event' or gesture becomes, at worst, just as much an art-object as the piece of drift-wood on the coffee table, or the seashell on the Victorian whatnot. At best, it becomes art. The truth is, you cannot hang an event on the wall, only a picture, which may be found to be beautiful or ugly, depending, alas, on your taste." Mary McCarthy, *On the Contrary* (New York: Farrar, Straus and Cudahy, 1961), p. 248.

26 "Painting is an island": In an essay first published in the third quarter of the nineteenth century, Edmond and Jules de Goncourt wrote of Chardin: "Modest in the midst of success, he liked to repeat the phrase: 'Painting is an island whose shores I have skirted.'" See Edmond and Jules de Goncourt, *French Eighteenth-Century Painters,* ed. and trans. Robin Ironside (London: Phaidon, 1948), p. 146.

27 "since the Renaissance at least": Charles Rosen, *The Classical Style: Haydn, Mozart, Beethoven* (New York: W. W. Norton, 1972 [1st ed. 1971]), p. 445.

27 "The laws of prosody and syntax": Edward Mendelson, *Early Auden, Later Auden: A Critical Biography* (Princeton, NJ: Princeton University Press, 2017), p. 335.

30 "You talk to me about 100 syllables!!": Giuseppe Verdi, *Letters of*

Giuseppe Verdi, sel., trans., and ed. Charles Osborne (New York: Holt, Rinehart and Winston, 1971), p. 135.

30 "write seven-syllabled lines twice": Ibid., p. 159.

30 "You will see that in the ballet": Ibid., p. 136.

31 "You will laugh when you hear": Ibid., p. 138.

31 "For singing": Ibid., p. 175.

31 "I should like the young student": Ibid., pp. 175–76.

33 "a technical handbook": Ingrid Rowland, "Introduction," in Vitruvius, *Ten Books on Architecture,* trans. Ingrid Rowland with commentary by Michael J. Dewar, Thomas Noble Howe, and Ingrid Rowland (New York: Cambridge University Press, 1999), p. 1.

33 "The Education of the Architect": Ibid., pp. 21–23.

33 "Just as in the human body": Ibid., p. 25.

34 Some three dozen pattern books: See Robert W. Scheller, *Exemplum: Model-Book Drawings and the Practice of Artistic Transmission in the Middle Ages (ca. 900–ca. 1470),* trans. Michael Hoyle (Amsterdam: Amsterdam University Press, 1995).

36 "Now, if you rely too much on ink": Susan Bush and Hsio-yen Shih, comp. and ed., *Early Chinese Texts on Painting* (Cambridge, MA: Harvard University Press, 1985), p. 182.

36 "A mountain has the significance": Ibid., p. 166.

37 "If there are exact sciences": Henry James, "The Art of Fiction," in *Literary Criticism* (New York: Library of America, 1984), p. 50.

37 "would be obliged to say": Ibid.

38 "are suggestive": Ibid., p. 51.

38 "the measure of reality": Ibid.

38 "what sort of an affair": Ibid., p. 49.

38 "Art lives upon discussion": Ibid., pp. 44–45.

39 "the power to guess": Ibid., p. 53.

39 "a kind of huge spider-web": Ibid., p. 52.

40 "not as high as Henry James thinks": E. M. Forster, "Terminal Note," in *Maurice* (Toronto: Macmillan of Canada, 1971), p. 239.

40 "*Names.* Osmond": *The Complete Notebooks of Henry James,* ed. with intro. and notes by Leon Edel and Lyall H. Powers (New York: Oxford University Press, 1987), p. 13.

40 "Phrases, of the people": Ibid., p. 32.

41 "a situation, or incident": Ibid., p. 13.

41 "been for years in love": Ibid., p. 23.

41 "his hand": Ibid.

42 "becomes free": Ibid.

42 "after a decent interval": Ibid.

42 "The situation might make": Ibid.

42 "it would take much more courage": James, "The Art of Fiction," p. 44.

3 THE IDEA OF VOCATION

45 "it didn't tire him": Gijs van Hensbergen, *Guernica: The Biography of a Twentieth-Century Icon* (New York: Bloomsbury, 2005 [1st ed. 2004]), p. 56.

46 "the artist acts like": Marcel Duchamp, "The Creative Act," in Jed Perl, ed., *Art in America: 1945–1970: Writings from the Age of Abstract Expressionism, Pop Art, and Minimalism* (New York: Library of America, 2014), pp. 454–55.

47 "She was full of secular intelligence": Katherine Anne Porter, *The Collected Essays and Occasional Writings of Katherine Anne Porter* (New York: Delacorte, 1970), p. 71.

47 "She wasn't even a heretic": Ibid.

49 "in the center of the royal family": Ibid., p. 157.

49 "that huge company of men": Ibid., p. 158.

49 "His life had classical shape": Ibid., p. 159.

50 "on the day of his death": Ibid.

52 "utterly enslaved": John Ruskin, *The Stones of Venice: Volume the Second: The Sea-Stories* (Sunnyside, Orpington, Kent: George Allen, 1886), p. 172.

52 "degradation": Ibid.

52 "Naturalism itself": Ibid., pp. 199–200.

53 "Every discriminating and delicate touch": Ibid., p. 201.

53 "Art is man's expression": William Morris, "Art, Labor, and Socialism" in Maynard Solomon, ed., *Marxism and Art: Essays Classic and Contemporary* (Detroit: Wayne State University Press, 1979 [1st ed. 1973]), p. 85.

53 "The pleasure which ought to go": Ibid.

53 "the unit of labour": Ibid., p. 87.

55 "show that by the eleventh": Meyer Schapiro, *Romanesque Art* (New York: George Braziller, 1977), p. 1.

55 "those ridiculous monsters": Ibid., p. 6.

55 "those unclean apes": Ibid.

55 "profane images of an unbridled": Ibid.

56 "He admires": Ibid., pp. 11–12.

56 "the church's splendor": Ibid., p. 14.

57 "is just propaganda": Flannery O'Connor, *The Letters of Flannery O'Connor: The Habit of Being,* sel. and ed. Sally Fitzgerald (New York: Farrar, Straus and Giroux, 1979), p. 157.

57 "art is wholly concerned": Ibid.

57 "You don't dream up a form": Ibid., p. 218.

58 "Vocation implies limitation": Ibid., p. 221.

61 *"Mille bombes incendaires"*: Hensbergen, *Guernica,* p. 45.

64 "the Spanish like violence": Ibid., p. 76.

65 "It has no sense of composition": Ibid., p. 72.

65 "is not an act of public mourning": Ibid., p. 76.

65 "least of all": Ibid., p. 77.

65 "a great painting": Ibid.

66 "from their conflict": André Malraux, *The Creative Act,* trans. Stuart Gilbert (New York: Pantheon, 1949), p. 121.

67 "I don't think that in any manner": Aaron Cohen, *Amazing Grace* (New York: Continuum, 2011), p. 28.

67 "Basically, yes, the feeling is still there": Ibid., p. 10.

67 "I did sing in the young people's choir": Ibid., pp. 2–3.

68 "cross between an eighth-note feel": Ibid., p. 40.

68 "shared early experiences": Ibid., p. 43.

68 "keyboardists on the *Young, Gifted and Black* album": Ibid., p. 44.

4 PHILOSOPHICAL SPECULATIONS

74 "conscious act of *construction*": Paul Valéry, "Introduction to the Method of Leonardo da Vinci," trans. Thomas McGreevy, in Valéry, *Selected Writings* (New York: New Directions, 1950), p. 101.

74 "who has never completed": Ibid.

76 "from the verb *augere*": Hannah Arendt, *Between Past and Future: Eight Exercises in Political Thought,* intro. by Jerome Kohn (New York: Penguin, 2006 [1st ed. 1961]), p. 121.

77 "always demands obedience": Ibid., p. 92.

77 "precludes the use": Ibid.

77 "implies an obedience": Ibid., p. 105.

77 "The authoritarian relation": Ibid., p. 93.

77 "all prototypes by which subsequent generations understood": Ibid., p. 119.

78 "all authority derives": Ibid., p. 123.

79 "general pattern and purpose": Isaiah Berlin, *Political Ideas in the Romantic Age: Their Rise and Influence on Modern Thought,* ed. Henry Hardy with intro. by Joshua L. Cherniss (Princeton, NJ: Princeton University Press, 2006), p. 91.

79 "Man is a rational being": Ibid.

80 "To be free is to understand": Ibid.

80 "The well-known Stoic argument": Ibid., pp. 90–91.

81 "The more precisely, fully and faithfully": Ibid., p. 185.

81 "only in so far as there is a law": Ibid.

91 "a strange, irrational quality": James S. Ackerman, *The Architecture of Michelangelo* (New York: Viking Press, 1961), vol. 1, p. 39.

91 "Everywhere in the vestibule": Ibid., p. 41.

91 "extravagant inventions": Daniel Sherer, "Error or Invention?: Critical Receptions of Michelangelo's Architecture from Pirro Ligorio to Teofilo Gallaccini," *Perspecta* 46 (September 2013): 84.

92 "dreadful to look at": Ibid., p. 86.

92 "bashing in the brains": Ibid., p. 85.

92 Palladio worried about: It was Palladio's belief, following Vitru-

vius, that because architecture imitates nature, it "cannot endure anything that alienates and distances itself from what nature permits." Because a tree is thicker at its base than at its summit, so the same qualities ought to be discovered in a column. Elements should grow one out of another in an orderly fashion. Ibid., p. 95.

93 "His association of architecture": Ackerman, *The Architecture of Michelangelo*, p. 5.

95 "long range movement": Charles Rosen, *The Classical Style: Haydn, Mozart, Beethoven* (New York: W. W. Norton, 1972 [1st ed. 1971]), pp. 185, 186.

95 "The most important fact": Ibid., p. 196.

97 "the sensation of an inexhaustible": Ibid., p. 260.

97 "an economy and restraint": Arthur Hutchings, *A Companion to Mozart's Piano Concertos* (Oxford and New York: Oxford University Press, 1989 [1st ed. 1948]), p. 191.

5 POSSIBILITIES

98 "All art begins as a struggle": André Malraux, *The Creative Act*, trans. Stuart Gilbert (New York: Pantheon, 1949), p. 138.

98 "arraign the universe": Ibid., pp. 15, 148.

99 "the greatest painters' supreme vision": Ibid., p. 118.

102 "In the grass sleepers sprawl": Edwin Denby, *The Complete Poems*, ed. and intro. by Ron Padgett (New York: Random House, 1986), p. 9.

102 "The traveling salesman helps me": Ibid., p. 107.

102 "The keen Propylea": Ibid., p. 108.

103 "Wild-eyed, ragged": Ibid., p. 111.

105 "The work of art must be 'produced'": Piet Mondrian, *The New Art—The New Life: The Collected Writings of Piet Mondrian*, ed. Harry Holtzman and Martin S. James (New York: Da Capo, 1993 [1st ed. 1986]), p. 289.

107 "No poet, no artist": T. S. Eliot, "Tradition and the Individual Talent," in *Selected Essays: New Edition* (New York: Harcourt, Brace & World, 1960), p. 4.

108 "What happens when a new work of art": Ibid., p. 5.

108 "an expression of *significant* emotion": Ibid., p. 11.

110 "the sacred text is smelted down": Gershom Scholem, *On the Kabbalah and Its Symbolism* (New York: Schocken, 1965), p. 12.

112 "the Fragment seems a model": *Questioning Minds: The Letters of Guy Davenport and Hugh Kenner*, ed. Edward Burns (Berkeley, CA: Counterpoint, 2018), vol. 1, p. 141.

112 "I think Pound came by": Ibid., p. 264.

113 "whether the visual arts": Ibid., p. 185.

113 "Naw. The connoisseur": Ibid.

113 "Brahms' Variations": Ibid.

113 "plagiarism, quotation, tag": Ibid.

115 "my great teachers": Anni Albers, *On Weaving* (Princeton, NJ: Princeton University Press, 2017 [1st ed. 1965]), p. v.

115 "It is interesting to note": Ibid., p. 24.

116 "For those of us concerned": Ibid., p. 34.

116 "the highly intelligent": Ibid., p. 51.

116 "infinite phantasy within": Ibid.

117 "that playful invention": Ibid., p. 52.

117 "a limitation must mean frustration": Ibid., p. 61.

6 A PLACE APART

121 I knew that some of the great modernists: One of the first books to deal forthrightly with the conservative strain in modernist literature was John Harrison's important and too-little-remembered *The Reactionaries: W. B. Yeats, Wyndham Lewis, Ezra Pound, T. S. Eliot, D. H. Lawrence*, with an introduction by the poet and critic William Empson (London: Victor Gollancz, 1966).

The book received an interesting review by Philip Rahv in *The New York Review of Books.*

124 "Kandinsky was a revolutionary painter": Kenneth Rexroth, *An Autobiographical Novel* (New York: New Directions, 1969 [1st ed. 1966]), p. 208.

125 "leisure-class culture": Peter Blume, "The Artist Must Choose," in *First American Artists' Congress* (New York: American Artists' Congress, 1936), p. 29.

127 "The effort to set art free": Leon Trotsky, *Literature and Revolution*, trans. Rose Strunsky, foreword by Lindsey German (London: RedWords, 1991 [1st ed. 1924]), p. 209.

127 "The very need of such an operation": Ibid.

127 "megalomania of aesthetics": Ibid., p. 210.

128 "without knowing what a medieval city was like": Ibid., p. 209.

129 "If words did not exist": Andrey Bely, "The Magic of Words," in *Selected Essays of Andrey Bely*, ed. and trans. Steven Cassedy (Berkeley and Los Angeles: University of California Press, 1985), p. 93.

129 "I thereby assert": Ibid.

129 "to be the creator": Ibid., p. 94.

129 "in a blind alley": Trotsky, *Literature and Revolution*, p. 83.

129 "Bely," Trotsky wrote: Ibid., p. 87.

129 "Torn from the pivot": Ibid., p. 81.

130 "the methods of formal analysis": Ibid., p. 209.

130 "How can we transform ourselves": Isaac Deutscher, *The Prophet Unarmed: Trotsky: 1921–1929* (London: Oxford University Press, 1959), p. 186.

130 "outraged the bureaucrat": Ibid., p. 197.

130 "complete freedom for art": André Breton and Leon Trotsky, "Manifesto for an Independent Revolutionary Art" (1938), in André Breton, *What Is Surrealism?: Selected Writings*, ed. and intro. by Franklin Rosemont (New York: Monad Press, 1978), p. 185.

130 "serve the struggle": Ibid., p. 186.

136 Almost immediately after Yeats died: A large literature has grown up around the question of Yeats and fascism—and Auden's response. George Orwell's 1943 essay on Yeats—although it doesn't mention Auden—may well be a response to Auden. There Orwell wrote that "a writer's political and religious beliefs are not excrescences to be laughed away, but something that will leave their mark even on the smallest detail of his work." (George Orwell, *The Collected Essays, Journalism and Letters of George Orwell*, ed. Sonia Orwell and Ian Angus [New York: Harcourt, Brace & World, 1968], vol. 2, p. 276.) For a brilliant response to Orwell, see Conor Cruise O'Brien's essay "Passion and Cunning: An Essay on the Politics of W. B. Yeats," in *In Excited Reverie: A Centenary Tribute to William Butler Yeats, 1865–1939*, ed. A. Norman Jeffares and K. G. W. Cross (New York: MacMillan, 1965). For a recent discussion of Auden's response to Yeats and the issues it raises, see the chapter "Persuasion and Responsibility: Yeats, Auden, Orwell," in David Bromwich's *How Words Make Things Happen* (New York: Oxford University Press, 2019).

136 "if one reviews the political activity": W. H. Auden, "The Prolific and the Devourer," in *The Complete Works of W. H. Auden*, vol. 2, *Prose: 1939–1948*, ed. Edward Mendelson (Princeton, NJ: Princeton University Press, 2002), p. 420.

137 "is not pretending to give an answer": Ibid., p. 421.

137 "If the criterion of art were": Ibid., p. 423.

138 "a profound understanding of the age": Ibid., p. 3.

138 "a working knowledge": Ibid.

138 "the filling up of a social quiz": Ibid., p. 5.

138 "the poet is a man of action": Ibid., p. 7.

138 "However false or undemocratic his ideas": Ibid.

139 "the opening section": Edward Mendelson, *Early Auden, Later Auden: A Critical Biography* (Princeton, NJ: Princeton University Press, 2017), p. 339.

139 "ritual and allegory": Ibid., p. 341.

140 "Earth, receive an honoured guest": W. H. Auden, *Collected Poems,* ed. Edward Mendelson (New York: Random House, 1976), p. 198.

140 "You were silly like us": Ibid., p. 197.

141 "Now Ireland has her madness": Ibid.

142 "Excluded by his cave": Ibid., p. 555.

A NOTE ABOUT THE AUTHOR

Jed Perl is a regular contributor to *The New York Review of Books*. He was the art critic for *The New Republic* for twenty years and a contributing editor to *Vogue* for a decade, and is the recipient of a Guggenheim Fellowship. His previous books include *New Art City, Antoine's Alphabet, Magicians and Charlatans,* and a two-volume biography of the American sculptor Alexander Calder. He lives in New York City.

A NOTE ON THE TYPE

This book was set in Janson, a typeface long thought to have been made by the Dutchman Anton Janson. However, it has been conclusively demonstrated that these types are actually the work of Nicholas Kis (1650–1702), a Hungarian. The type is an excellent example of the influential and sturdy Dutch types that prevailed in England up to the time William Caslon (1692–1766) developed his own incomparable designs from them.

TYPESET BY SCRIBE, PHILADELPHIA, PENNSYLVANIA

PRINTED AND BOUND BY LAKESIDE BOOK COMPANY, CRAWFORDSVILLE, VIRGINIA

DESIGNED BY MAGGIE HINDERS